Wolves, Coyotes & Foxes

Symbols of the Wild

Written and Photographed by
STAN TEKIELA

Adventure Publications
Cambridge, Minnesota

Cover photo by Stan Tekiela
All photos by **Stan Tekiela** except pg. 157 (Island Gray Fox) by **BlueBarronPhoto
/Shutterstock.com**; pg. 157 (Kit Fox) by **Rick and Nora Bowers**, and pp. 2 & 5 (wolf
silhouettes) by **steffiheufelder/Shutterstock.com**. Some photos were taken under
controlled conditions.
Edited by Sandy Livoti and Brett Ortler
Cover and book design by Jonathan Norberg

10 9 8 7 6 5 4 3 2 1
Wolves, Coyotes & Foxes: Symbols of the Wild
First Edition 2012 (entitled *The Lives of Wolves, Coyotes and Foxes*)
Second Edition 2022
Copyright © 2012 and 2022 by Stan Tekiela
Published by Adventure Publications
An imprint of AdventureKEEN
310 Garfield Street South
Cambridge, Minnesota 55008
(800) 678-7006
www.adventurepublications.net
ISBN 978-1-64755-315-9 (pbk.); 978-1-64755-316-6 (ebook)

Dedication

This book is dedicated to all those who feel a special bond and connection deep in their souls to wolves, coyotes and foxes—the wild canids. I hope you feel the same thrill that I do whenever I see or photograph one of these magnificent animals.

Acknowledgments

Special thanks to Peggy Callahan, wildlife biologist, wolf expert and extraordinary friend, for reviewing this book. Your extensive knowledge of wolves is legendary and is so greatly appreciated. Thanks for dedicating your life to these amazing predators.

Thanks!

Contents

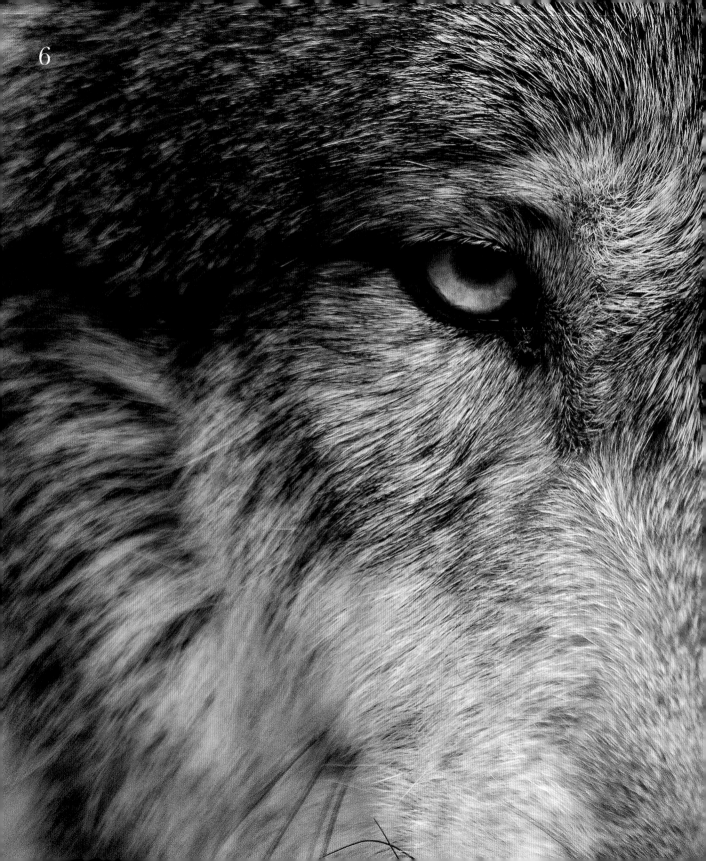

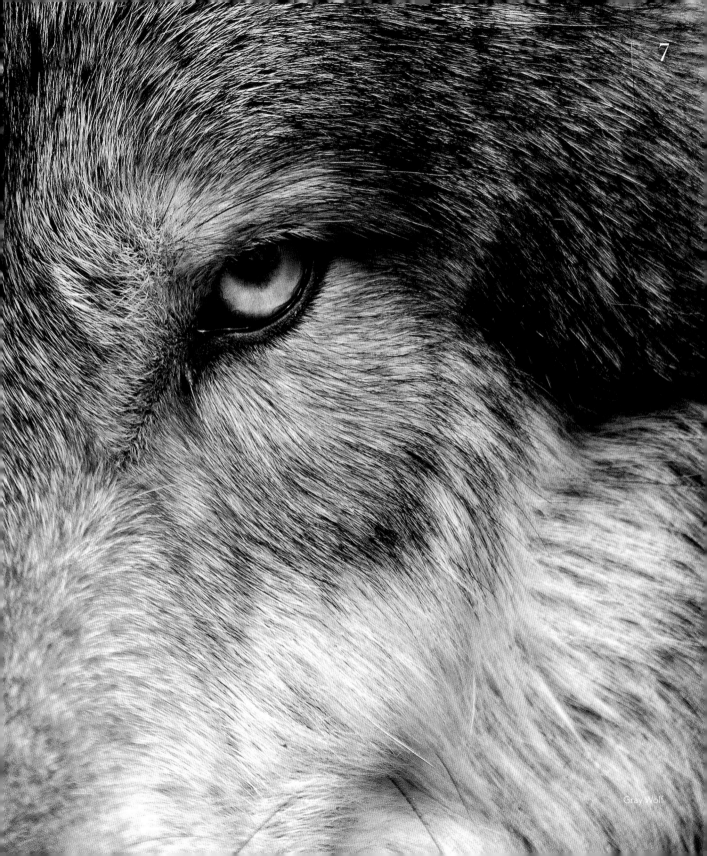

Gray Wolf

Wolves—a symbol of all things wild

Few animals in the wilderness elicit such strong emotions in people as the wolf. Wolves are loved by many who cherish wild places and intact ecosystems, but they are loathed by others who regard them as competition for natural resources. I find wolves to be a symbol of all things wild—the epitome of wildness! I live in Minnesota, a state with more wolves than any other in the Lower 48. Living in close proximity to them makes me feel more connected to the wild, and for that I am grateful.

Wolves, along with coyotes and foxes, are a group of animals that I've always found fascinating throughout my career as an author, naturalist and wildlife photographer. I have been studying and photographing wolves in particular for more than three decades, but I still get excited each time I see one through my viewfinder. I suspect this will always be the case because they are, strangely enough, lovable, intelligent creatures—much like the many domestic dogs I've known.

Stan Tekiela

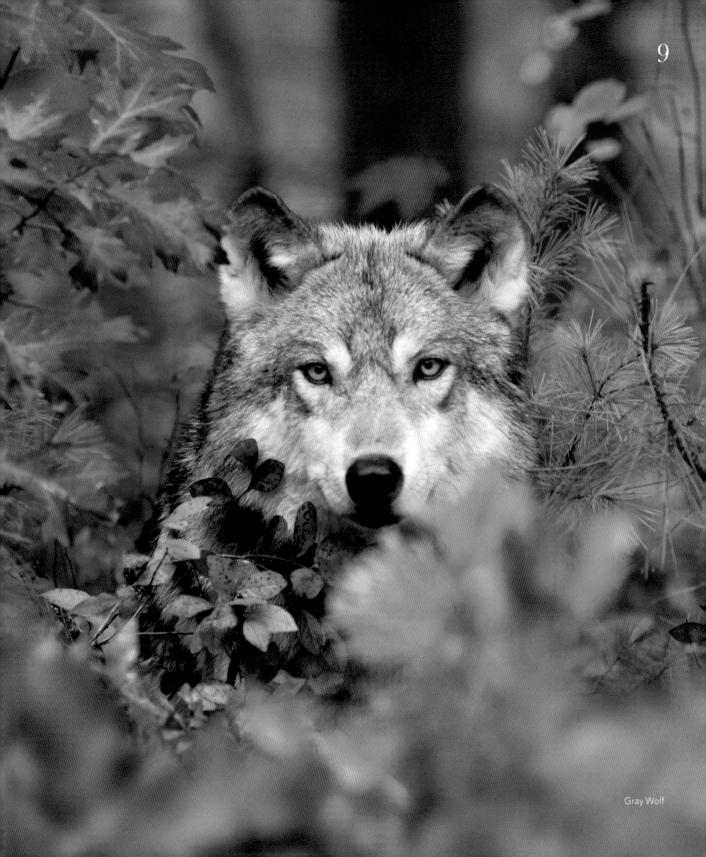

Gray Wolf

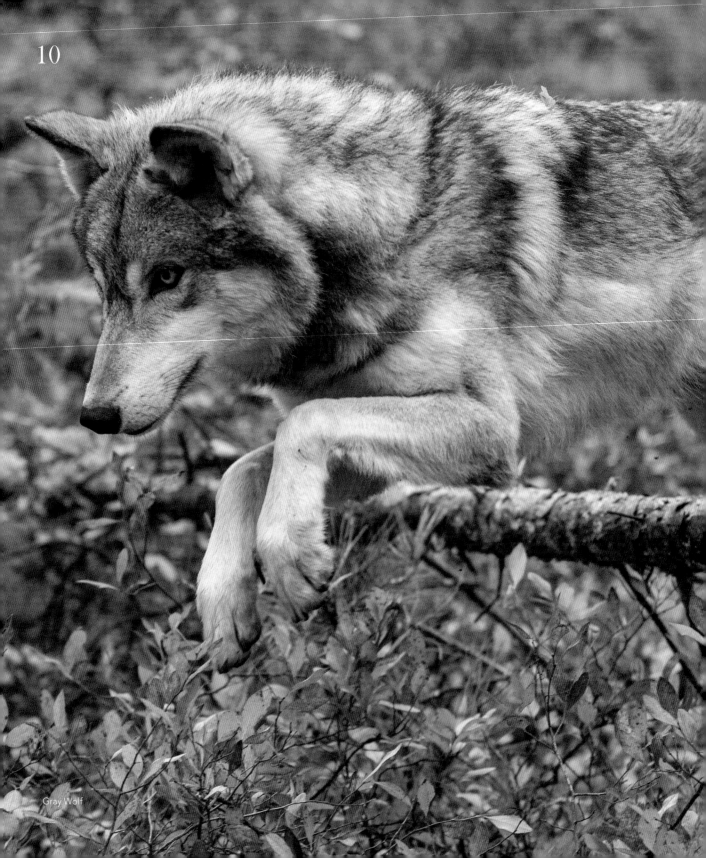

Gray Wolf

Ancient times

Early humans and wolves no doubt shared similar regions worldwide and competed for food. Both were top predators, living and hunting in family units and traveling to hunt for food. They both stayed in groups year-round and were fairly long-lived. Both used complex communication and taught survival skills to their young. Their coexistence must have led to many encounters, and humans must have noticed the similarities. This is in all likelihood how the relationship between wolves and people began.

The wolf spirit

Some long-ago cultures around the world believed that wolves were their brothers. The early American Indians and other Indigenous peoples also had a kinship with wolves and their ways. While many tribes feared wolves, others respected wolves for their power and even more for their intelligence. Both American Indians and First Nations people killed wolves only out of the need for fur for clothing and teeth and claws for trade, and they often made apologies to the sacred wolf. For them, the wolf didn't represent something to fear or obliterate. They didn't speak harshly about wolves or brag about killing them. To do that, it was thought, would offend the wolves and bring bad luck and lead to hard times.

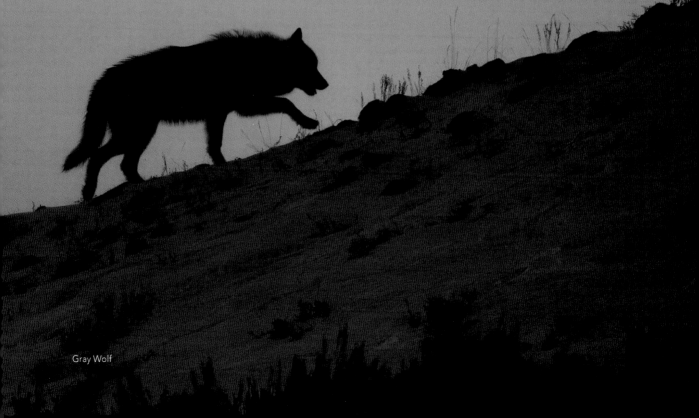

Gray Wolf

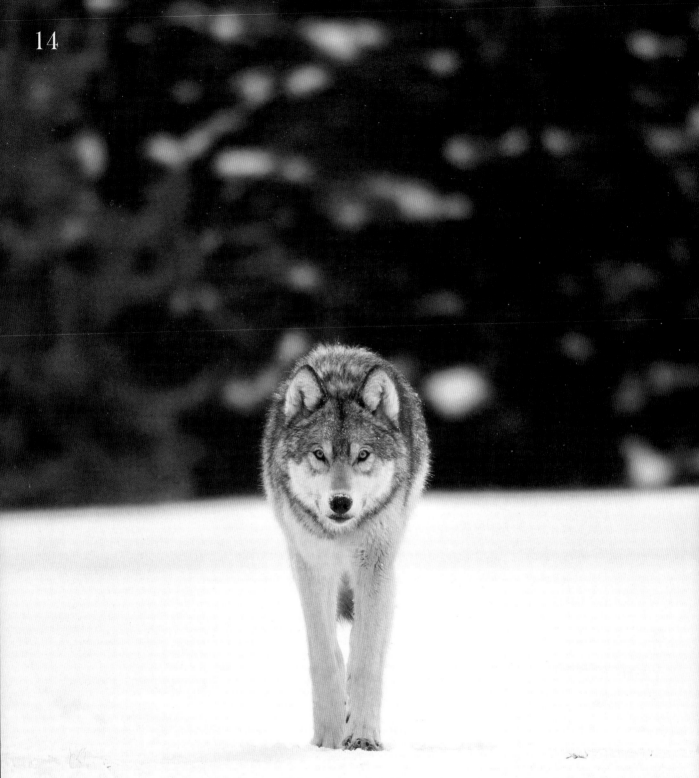

Gray Wolf

Indigenous peoples of the American West and Great Plains saw the wolf as master of the hunting craft. They wore wolf-skins when scouting for prey, believing it would help them hunt like the great wolf. They also believed that wolves understood their language and would even warn them about enemies nearby. Obviously, the spiritual relationship between people and wolves was close—and in some circles, still is today. Even now, the wolf continues to be regarded by some as a brother, teacher and spirit guide.

Wolves and the colonists

Based on Old World mythology, the European colonists brought to the New World a fear and hatred of wolves. Settlers depended on domestic livestock, unlike the Indigenous peoples, who were reliant on wild game. Wolves were seen as wanton killers and competitors for food. Livestock was easy prey for wolves and needed to be protected.

Eradication programs started right away. During settlement times, the rate at which wolves were killed reached a fevered pitch, and thus began the longest, most sustained and relentless persecution of a species. Other animals, such as coyotes and cougars, were also targeted. In addition to the outright killing of wolves, populations of deer, elk, moose and bison were decimated by hunters for the colonial marketplace. As large prey in the wild became scarce, the remaining wolves were forced to switch their diet to livestock. This brought wolves into more conflict with people.

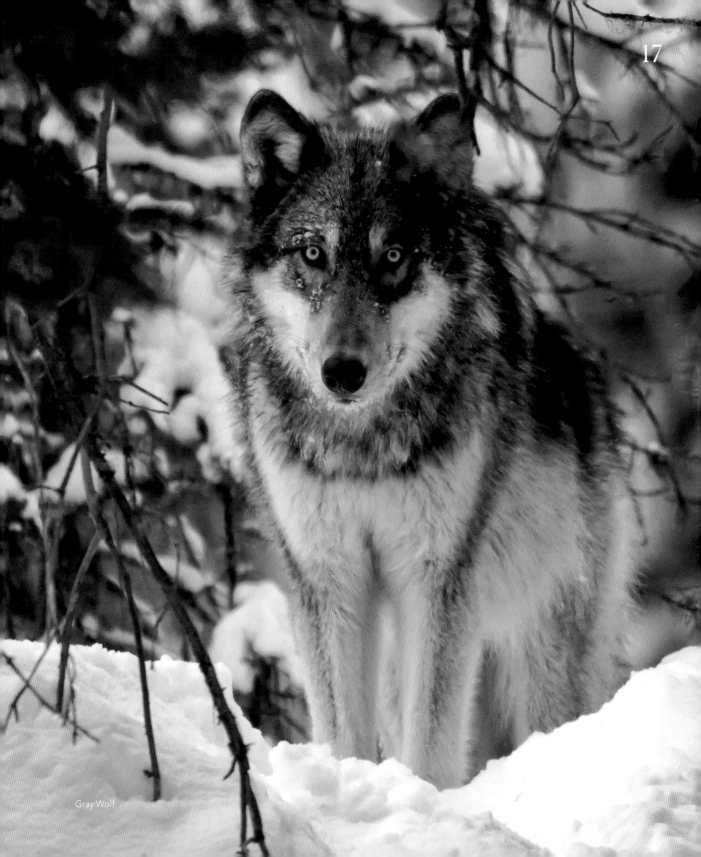

Gray Wolf

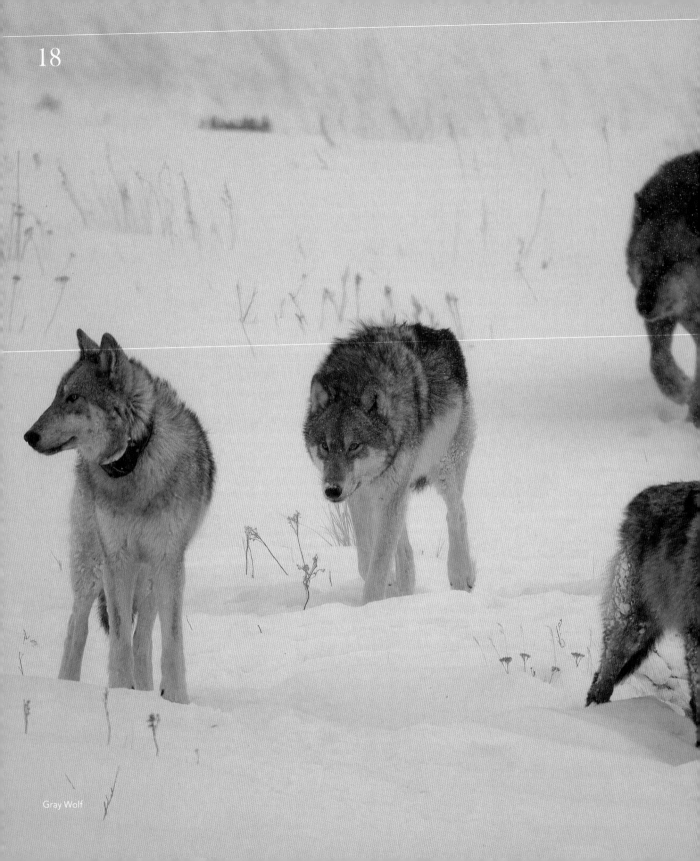

Gray Wolf

Wolves in the twentieth century

By 1905, the United States Congress established the Bureau of Biological Survey to eliminate all wolves and other large predators from all lands in order to protect livestock. At that time and in the decades to follow, the wolf was denigrated and stories circulated that rogue wolves were roaming around, killing livestock just for the sake of killing. The bureau generated many of these reports in an effort to maintain funding. In 1924, federal biologist Edward A. Goldman declared, "Large predatory mammals, destructive to livestock and game, no longer have a place in our advancing civilization."

It wasn't until the 1940s, when the wolf was eliminated from nearly all regions, that people started to speak out in favor of the wolf. Aldo Leopold (1887-1948), a conservationist who is considered the father of wildlife management, was one of the first to come to the defense of wolves. He himself had hunted wolves when he was young, but he wrote about his heartrending experience of watching an old wolf's "fierce green fire dying in her eyes" as a result of his gunshot, and it helped to change his ways. In 1944, Leopold proposed restoring wolves to Yellowstone National Park, where they had been completely eradicated for nearly two decades. Sadly, about 50 more years would pass before that restoration would even begin.

Other conservation efforts and knowledgeable biological decisions about wolves were initiated during the 1950-60s. With the birth of the environmental movement in the 1970s came the Endangered Species Act of 1973 and other major environmental laws. From these beginnings, many organizations formed to help protect and preserve wolves.

The canine family

The Canidae (pronounced "KAN-e-dee") family is a group of carnivorous, doglike mammals that includes wolves, foxes, coyotes, jackals and domestic dogs. Members of this family are often just referred to as canids. Canids can be split into two main groups or tribes—wolflike animals and foxes. In this book, only the nine canid species in North America are considered. They are the Gray Wolf, Red Wolf, Coyote, Red Fox, Gray Fox, Swift Fox, Kit Fox, Arctic Fox and Island Gray Fox.

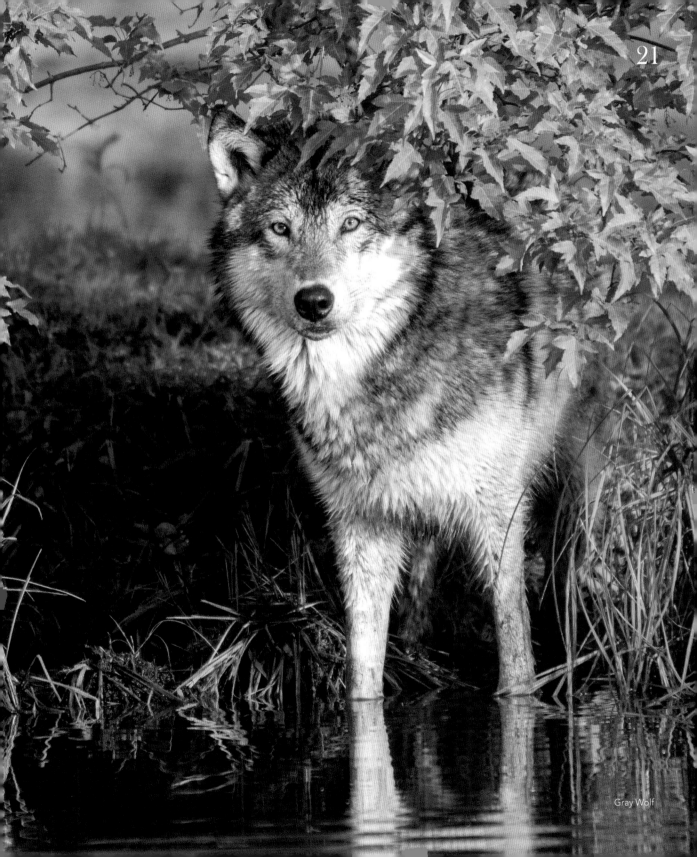

Gray Wolf

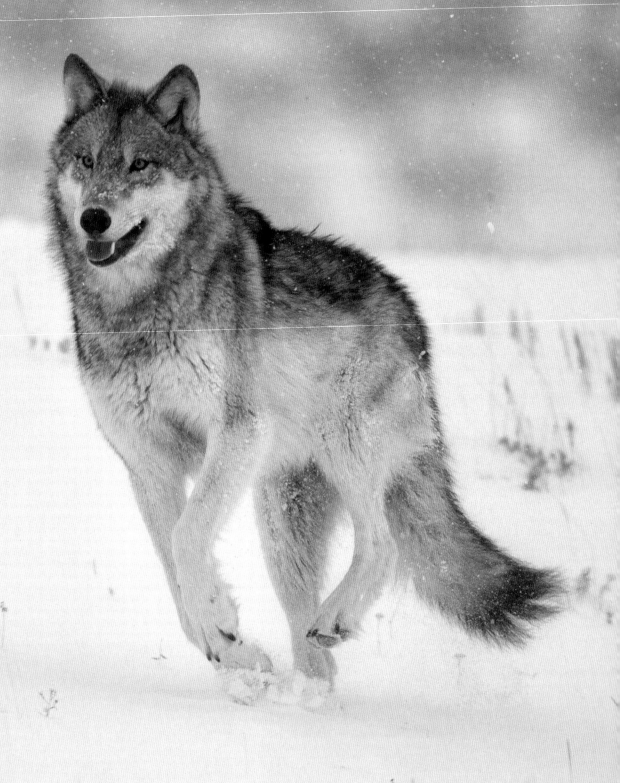

Gray Wolf

Origins of the species

The genealogy of the wolf is not completely clear, but it appears that ancestors of the carnivorous wolf started in the Paleocene, 60 million years ago. The family lines of carnivorous dogs and cats that are recognizable to us today began 20 million years ago during the Miocene. A million years ago the closest ancestor of our modern wolf emerged with a larger skull and brain. It had a long snout and was well adapted to running and chasing prey. Our modern wolf, the Gray Wolf (*Canis lupus*), is smaller and has a higher forehead than the original wolves. Wolves today also have a more complex social structure and live in cooperating family units.

Like the closest ancestor of the modern wolf, coyotes appeared 1 million years ago. They are close relatives of wolves indeed, with a genetic difference of less than 1 percent.

It was sometime later that foxes became apparent and established. Foxes are unique and not closely related to wolves and coyotes. Dogs were domesticated only 15,000–30,000 years ago, which is recent compared with the long lineage of the wild canids.

Wolves around the world

Wolf and wolflike ancestors have been found on every continent except Antarctica. These large predators thrived in a wide range of habitats, from mountains and forests to deserts and prairies, and there was no place they couldn't find a home. They are Holarctic, which means they once occupied most of the Northern Hemisphere above 30 degrees north latitude. They roamed throughout Europe, the Middle East and south into Saudi Arabia. Wolves were also found in Russia, India and China. In North America they ranged across all Canadian provinces and American states and reached as far south as central Mexico. Unfortunately, they were eliminated from 99 percent of all regions. There are a few left in Russia, China, northern Spain and the mountains of Italy and Germany, but their numbers are greatly reduced.

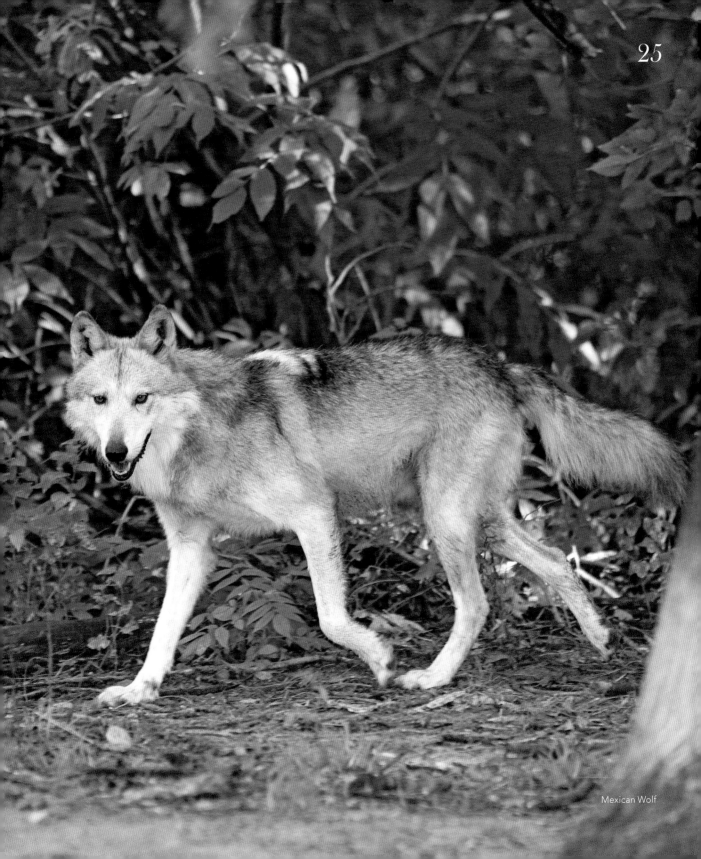

Mexican Wolf

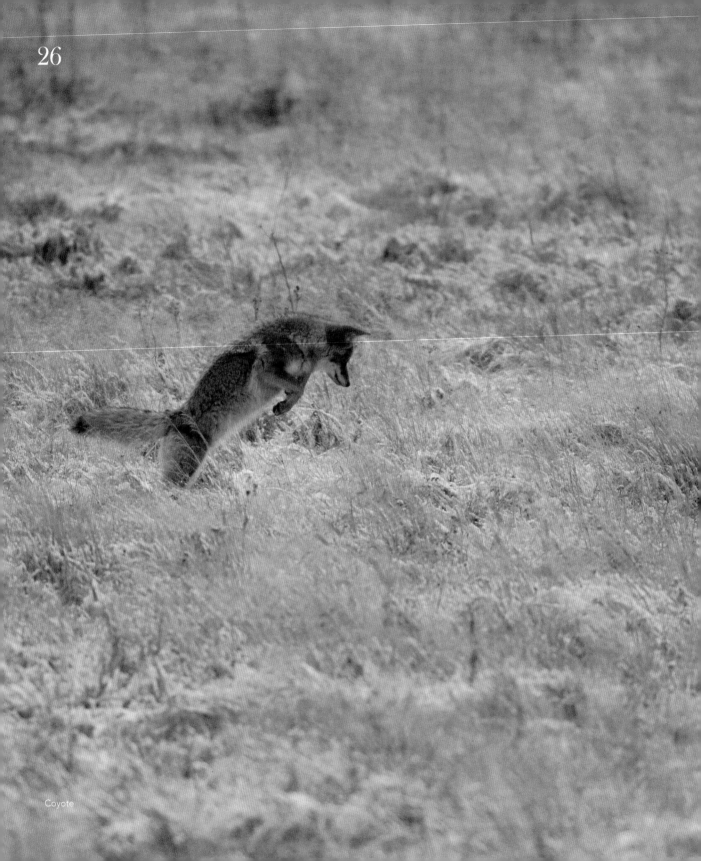

Coyote

Family traits

All canids have relatively long legs, giving them the ability to reach sufficient speeds to catch prey or spring high into the air to pounce on prey. They are considered digitigrade mammals, meaning they walk on their toes at all times, unlike many other mammals that walk on flattened feet. In addition, they don't have retractile claws, like cats. They also have a dewclaw on each front foot. A dewclaw is the lone claw positioned rather high on what seems to be the front leg but actually is part of the foot.

Canids are well-furred animals with just the pads of their feet and nose tips exposed to the elements.

All canine members have long, bushy tails. Canids often curl up and nuzzle their noses into their tails to help keep warm at night. They also use their tails as visual communication among pack members, much like a flag. Most have long, pointed muzzles and strong jaw muscles, which help them deliver killing bites to prey and tear open flesh and even bone.

All young canids are born helpless, with their eyes closed and ears sealed shut. They depend entirely on their mother until their eyes open, which happens within a few weeks.

Discovering subspecies

A species that has variations is biologically organized into subspecies. A species will either be divided into at least two subspecies or it will have no subspecies. There cannot be one subspecies of a species, and a subspecies cannot be classified by itself. Subspecies are differentiated from the main species by physical attributes, such as color or size, or, in a less obvious way, by DNA sequencing.

The number of subspecies of wolves, coyotes and foxes is constantly changing. There are currently as many as 40 wolf subspecies, including the Arctic Wolf, the Mexican Wolf and 2 domestic dog subspecies. Wolf subspecies are split into two groups—northern wolves and southern wolves. While there are northern wolf subspecies in North America, this book focuses primarily on the main species. In our appreciation of wolves, the Gray Wolf is the first and foremost.

The coyote is thought to have 19 subspecies, with 16 occurring in the United States, Canada and Mexico. These are differentiated chiefly by size and habitat. Since 2018, Red Foxes have held a total of 30 subspecies in the Old World and 9 subspecies in the U.S., Canada and Mexico. As we learn more about the DNA of main species, the number of subspecies will continue to change and be refined.

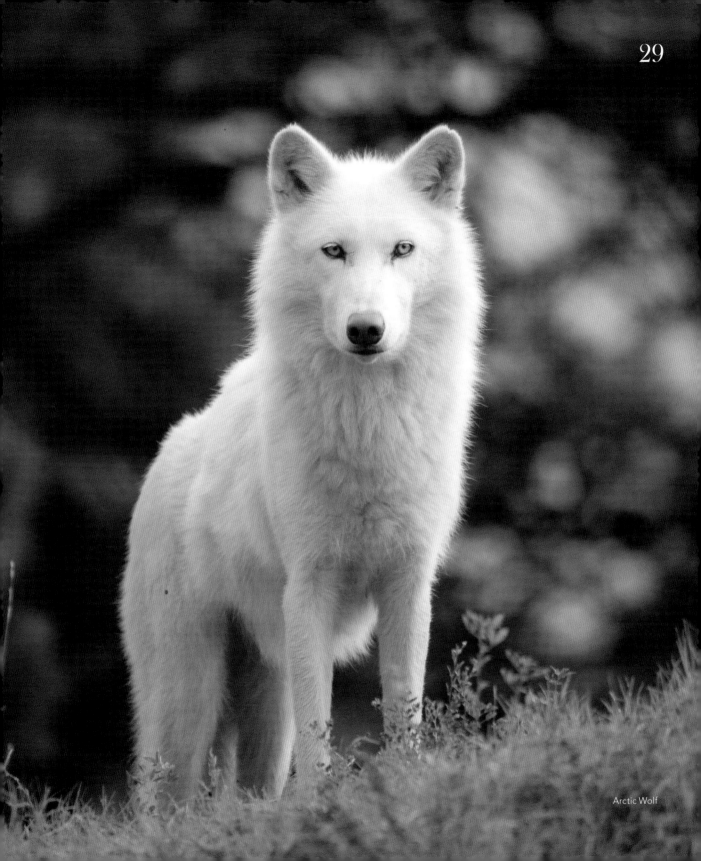

Arctic Wolf

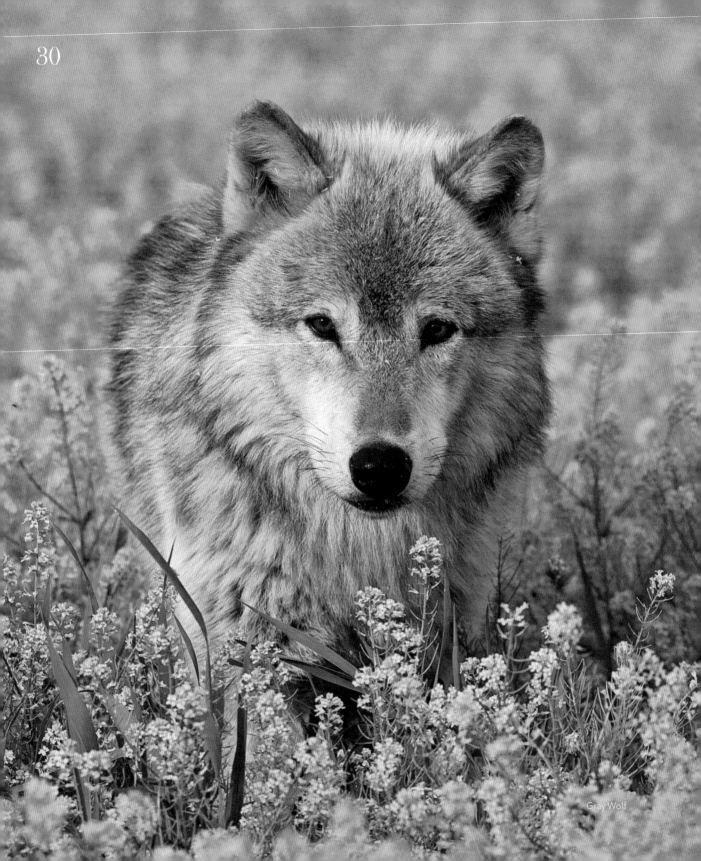

Gray Wolf

Popular names

Wolves have acquired different common names across their range. For example, in Minnesota the Gray Wolf is often called the Timber Wolf. It also has a slew of other names, including Lobo, Lone Wolf, Common Wolf, Plains Wolf, Tundra Wolf, Arctic Wolf, Mexican Wolf and Brush Wolf. The coyote is also known as Brush Wolf, and Prairie Wolf. It is easy to see how multiple common names only lead to more confusion and misinformation about wolves and coyotes—especially when the popular names, such as Arctic Wolf and Mexican Wolf, are the same as the subspecies names.

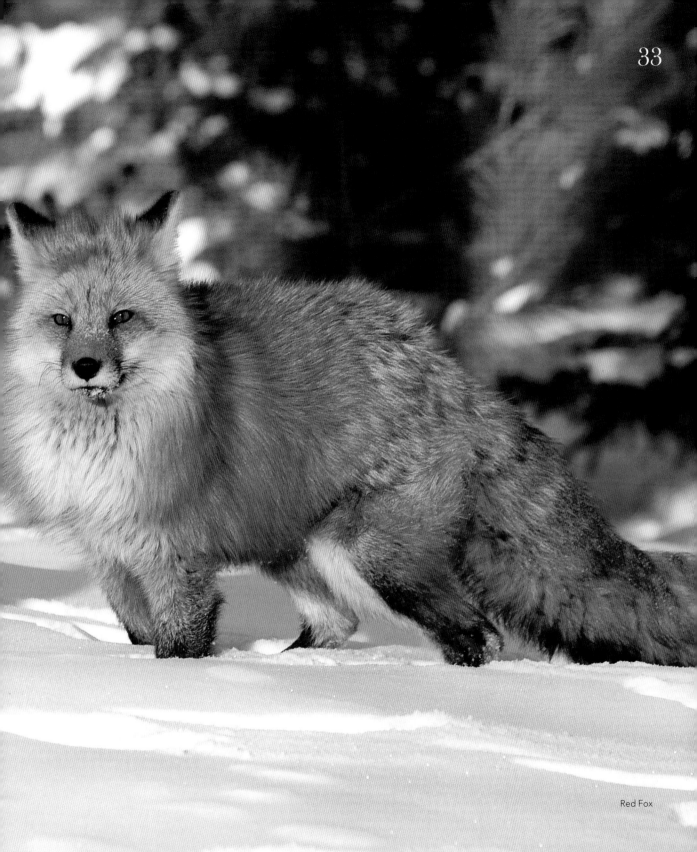

Red Fox

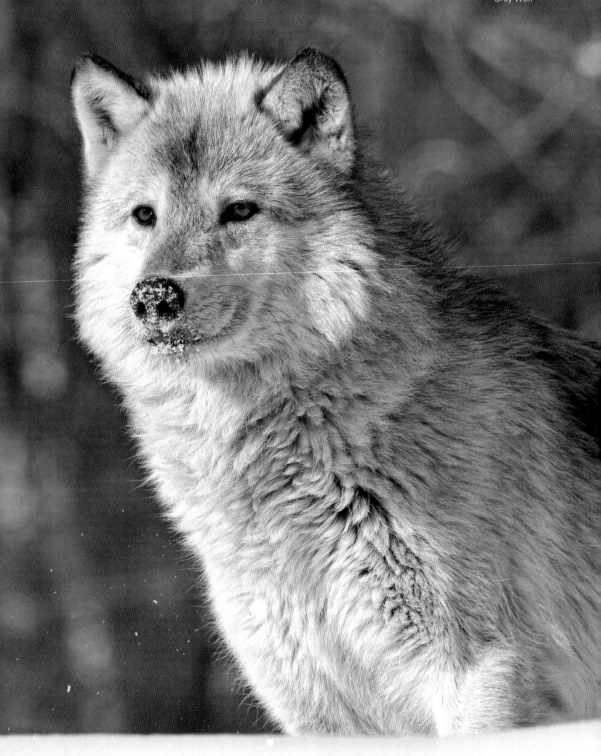

Sizes north to south

With the exception of some large breeds of domestic dogs, Gray Wolves are the largest members of the canid group. Their body size varies slightly across their range. For example, wolves in Alaska and northern Canada are the largest and heaviest. Farther south, their size decreases slightly. The Mexican Wolf (*Canis lupus baileyi*), a subspecies of Gray Wolf, is the smallest wolf in North America.

The size discrepancy also applies to coyotes and foxes. The biological reason for this difference is explained by a number of variables, such as the abundance of prey and genetics, as well as Bergmann's Rule, which states that an animal species in colder climates retains body heat more efficiently than the same animal species in warmer climates. The more the body mass, the more heat is retained and the easier it is for an animal to stay warm, and a smaller or thinner animal with less body mass expends its body heat more quickly and remains cooler in warmer environments. Thus, the farther north, the larger the animals, and vice versa.

Weights and measures

The largest wolves live in Alaska and northern Canada and weigh about 120 pounds. Larger individuals on record include a 175-pound wolf (Alaska, 1939) and a 172-pound wolf (Canada, 1945). In general, male wolves are larger and heavier than females by about 5-10 pounds. Adult wolves in the Lower 48 weigh around 80 pounds, with heavier animals in northern regions and lighter individuals in southern regions. They stand 33-35 inches tall at the shoulders and are 50-63 inches in length from snout to tip of tail. The tail is approximately one-third the length of the head and body and averages 15-20 inches.

Coyotes are only one-quarter to one-half the average weight of wolves, about 20-40 pounds. They are around 24 inches tall at the shoulders and have a length of 36-40 inches from snout to tip of tail. Like wolves, the coyote tail has the same one-third proportion to the body, measuring approximately 12-15 inches in length.

Red and Gray Foxes are even smaller yet. Red Foxes weigh 7-15 pounds and are only slightly larger than Gray Foxes. One of the largest foxes caught was recorded to weigh 26 pounds. Swift and Kit Foxes are the smallest, with the Swift averaging 3-7 pounds and the Kit weighing in at only 3-6 pounds. Red Foxes stand 15-16 inches tall at the shoulders and are 20-30 inches in length from snout to tip of tail. Fox tails are very thickly furred and disproportionately large for such small animals. Tail lengths in Red and Gray Foxes average 13-17 inches, with Swift and Kit tails being proportionately smaller.

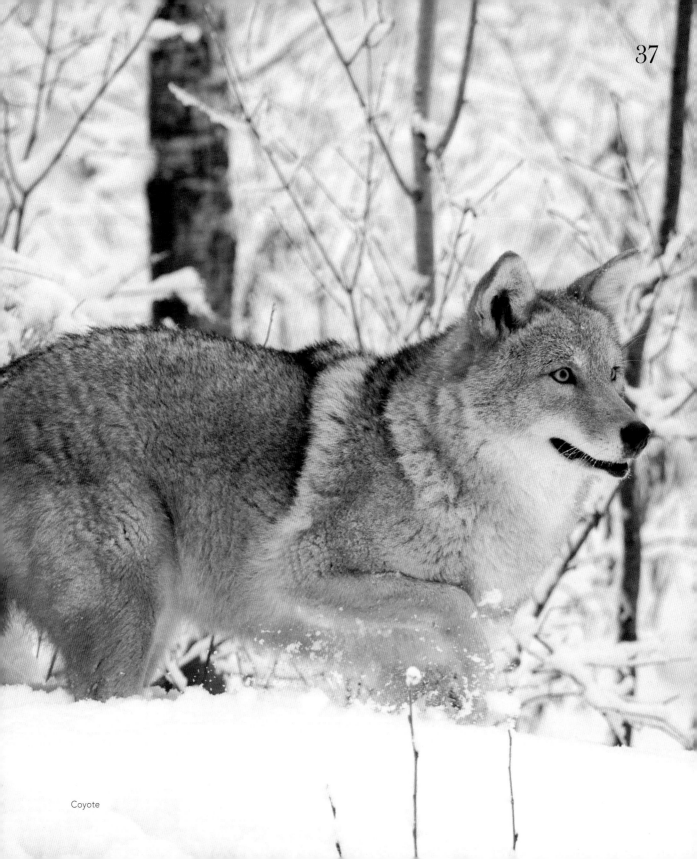

Coyote

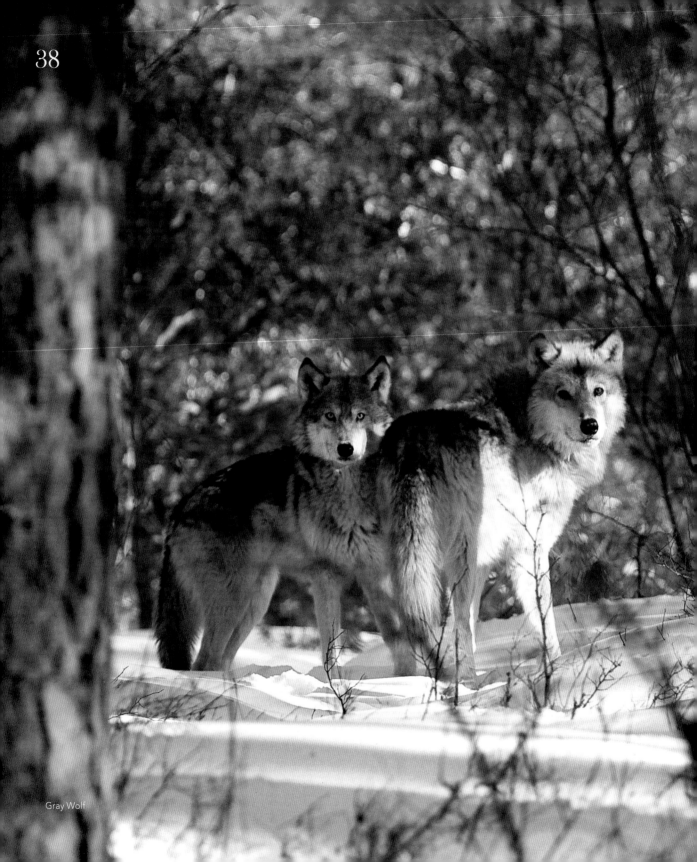

Gray Wolf

Canid males have a larger average size and weigh more than females, but there are exceptions. I photographed a female wolf that was not only noticeably taller and wider than the males in her pack, but she could also take down large prey, such as elk, by herself. Rarely can a single wolf accomplish such a task.

Life expectancy

A wolf's life is difficult at best. The dynamics of the pack puts pressure on its leaders, which usually are the strongest and oldest members. They are continually watched for hints of weakness and vulnerability. If a flaw is not evident, young wolves test the leaders to assess their overall physical ability. When weakness is perceived, a series of confrontations commences. Often these are uncompromising battles, sometimes resulting in serious injuries or death. Thus, the life expectancy of wolves tends to be fairly short.

Overpowering large prey is also dangerous. If a wolf weighs only 80–100 pounds, taking on an elk or bison that weighs 500–1,500 pounds is treacherous, if not fatal. In addition, a hard-won kill is sometimes stolen by a hungry Grizzly Bear or other large predator, adding to the dangers of hunting. A single wolf is no match for a grizzly, and the bear will always win the inevitable conflict. It's not uncommon for a pack member to suffer serious injuries from hunting or to die while trying to defeat large prey or an intruder at the kill site. One well-placed kick from the hoof of a powerful bison or deep slashes from bear claws are enough to kill a wolf.

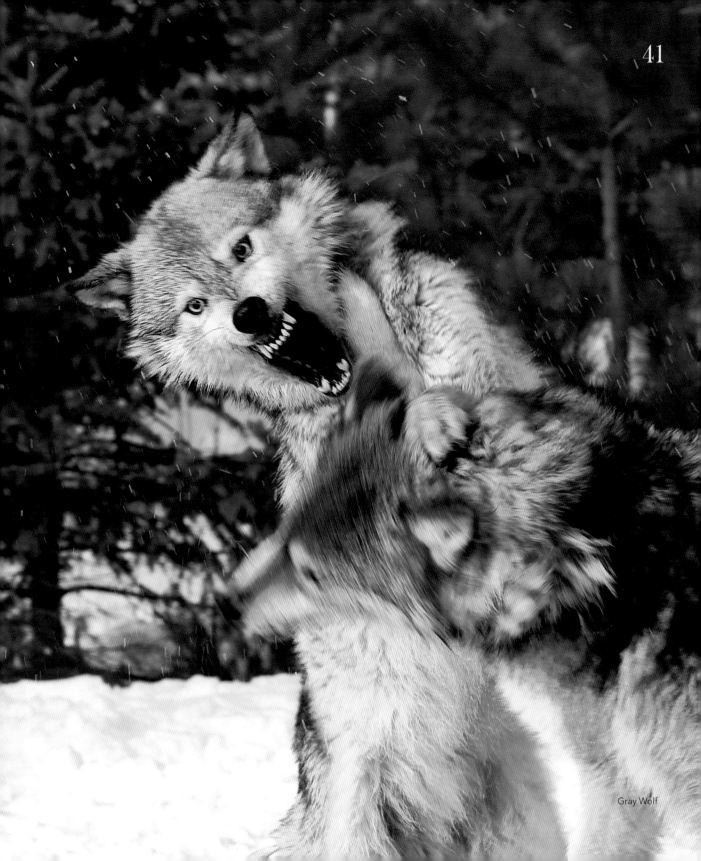

Gray Wolf

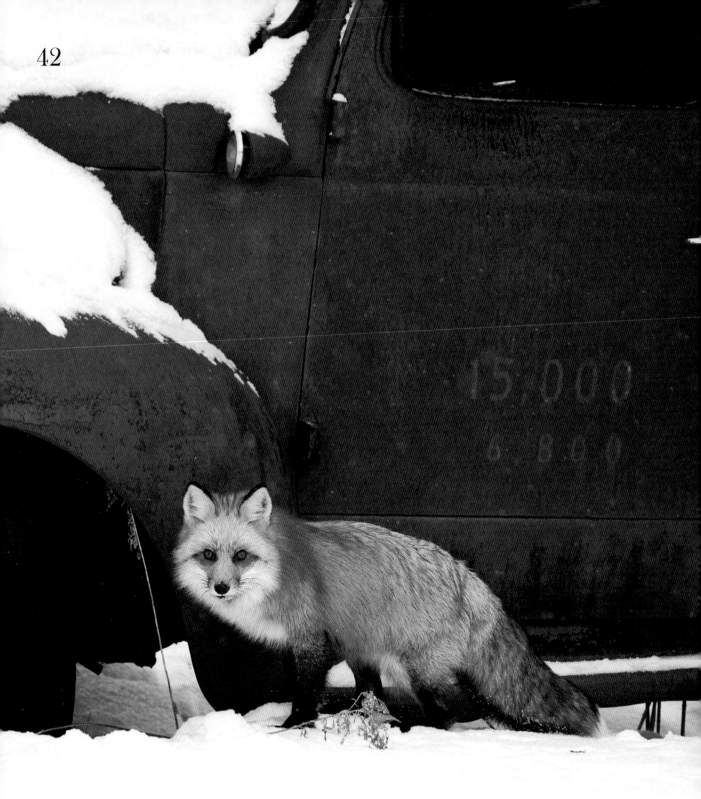

Red Fox

Diseases, such as rabies, COVID-19, canine distemper and parvovirus, and parasites, such as heartworms and sarcoptic mites (mange), shorten the lives of many wolves. Adverse contact with people, whether by car collision or shooting, trapping or poisoning, also reduces the life expectancy.

Wolves in the wild live about 4-6 years. At these ages, they are at their peak physically. Some individuals survive as long as 15 years, but this is uncommon. In captivity, where disease and competition are limited, wolves can live 20 years. Wolves live a fast and violent life, usually meeting their demise well before they've grown old.

Coyotes are survivors, normally staying out of harm's way. However, as top predators, coyotes face all the same dangers in life as wolves, and they have a similar life expectancy, with most averaging 5-6 years. For a coyote, 10 years is fairly old. Their record life span in the wild is 14 years. In captivity they can live more than 20 years.

Foxes are less fortunate. They face the same trials and tribulations as wolves and coyotes, but they don't fare as well. Disease and human contact are the major reasons for fox mortality. The average Red Fox lives only a short 3-4 years, although some make it to 6-7 years. Swift and Kit Foxes live even shorter lives, just 2-4 years. The oldest foxes in the wild survived to 12 years of age.

Essential habitat

The correct habitat is essential for an apex predator such as the wolf. Wolves need abundant prey, be it large or small, and free movement in tracts of land uninhabited by humans. Only when the natural food supply becomes scarce or when people encroach into wolf territory will a pack experience problems with humans.

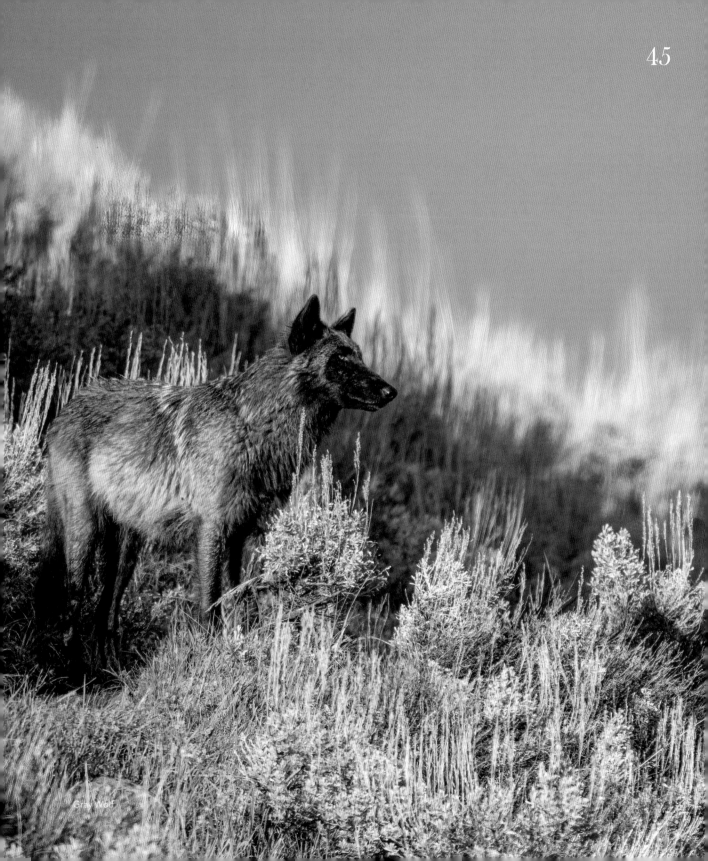

Gray Wolf

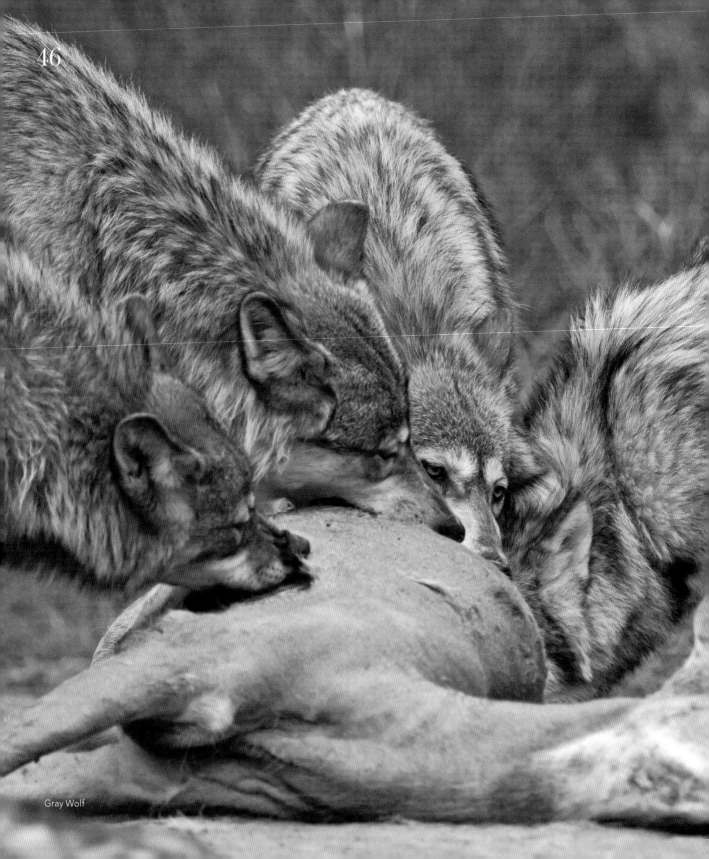

Gray Wolf

Hunting to survive

Oddly, many people think that wolves are bloodthirsty killers that roam the countryside, killing whatever they find for no good reason. The same is said about coyotes. This notion is simply not true. The fact is that wolves are just trying to survive from day to day. Without a kill, they go hungry. Food shortage leads to a weakened state, making it harder to catch prey. For these animals, each kill is a matter of life and death—their own. It is not for sport or bloodthirst.

Hunting in packs

There are good reasons for wolves to hunt in a pack. Wolves feed on much larger prey for their main diet, so hunting with others and sharing both risks and bounty works well. Cooperative hunting has disadvantages, however. Several studies showed that the larger the pack, the less food each member receives. A Minnesota study showed that a pack of five wolves killed fewer prey per wolf than a lone wolf. Large packs also killed fewer prey per wolf than pairs of wolves, indicating that smaller packs have the advantage over larger packs. When a pack reaches 12 or more members, efficiency decreases because each wolf gets less food.

Pack size is often in proportion to the size of the prey. Wolves that feed on deer are often in smaller packs, while wolves that hunt elk, moose or bison are usually in larger packs. One pack in Yellowstone has as many as 35 individuals.

Much of the information we know about wolf packs also relates to coyotes. Coyotes work together in the same ways as wolves, in similar packs. Coyotes, which form small, loose packs, hunt for smaller prey, such as rabbits and hares, while lone coyotes hunt mice, voles and shrews.

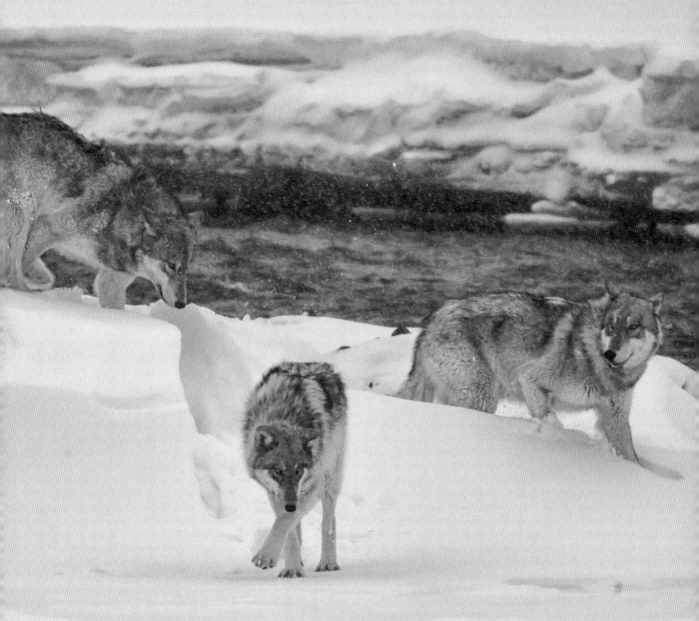

Gray Wolf

Gray Wolf

Guiding the pack

Many are familiar with the concept of the dominant (alpha) male and alpha female being the leaders and that they are the only breeding wolves in a pack. However, studies from Minnesota packs in the wild and captive packs show that, in many cases, the alpha male may be in charge, but his position does not make him the sole decision maker. Usually all pack members influence what the pack does, and the alpha male (or alpha female) guides the pack on the decision made.

Then again, I witnessed a wild pack in which an alpha female was the dominant leader. She decided when and where to hunt and always traveled at the head of the pack. So leadership is often a mixed scenario. The preconceived notion that the alpha leader, be it male or female, is always the only decision maker, in front at all times, the first to eat and dominant over the entire pack is not what actually happens in the average pack. It's much more complicated than that.

Family ties

It might be fair to compare the wolf pack with the human family unit. A breeding adult pair and their offspring lead a wolf pack. The offspring may be from the current year or the previous season. Most wolf young (pups) take up to 2 years to fully mature and learn how to hunt. Some mature at 1 year and are fully functional and ready to breed. Other pups stay with their parents for up to 4 years before they are ready to disperse. Because the young mature at different rates, the family needs to stay together for long periods, and that naturally creates the pack.

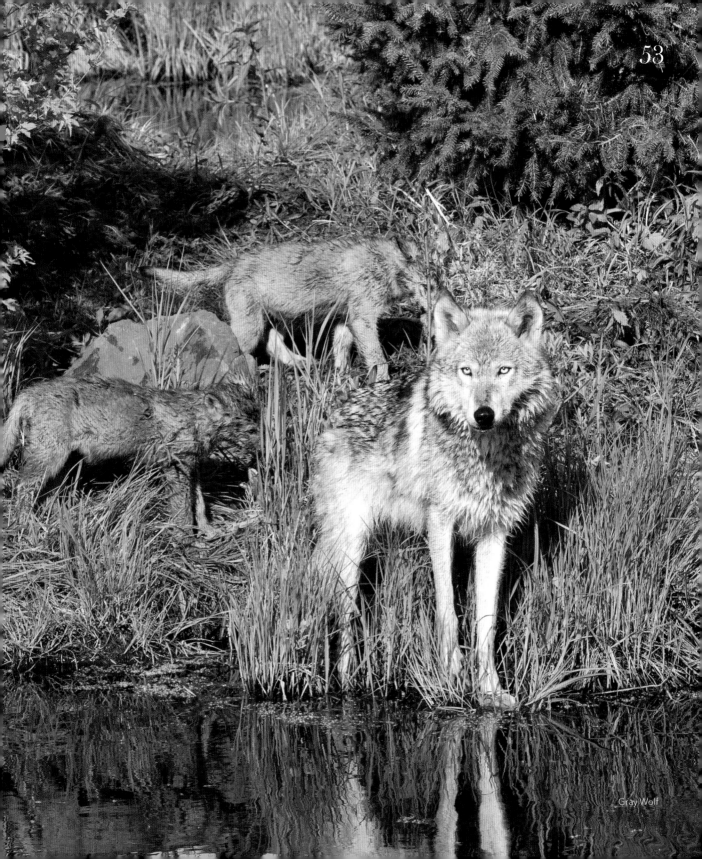

Gray Wolf

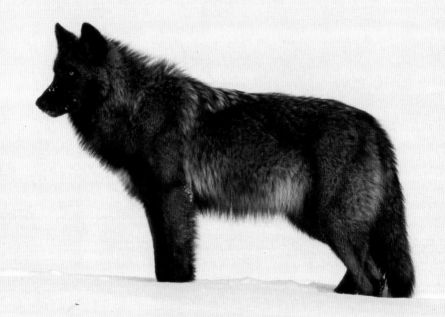

Gray Wolf

Dispersal from the pack

Most young wolves eventually leave their birth (natal) pack. In most cases, young wolves depart for short periods before returning. This might happen a half-dozen times before they finally leave for good. Others disperse once and never come back. Rarely, a youngster will take over the alpha or dominant breeding role in its own pack and remain.

Often a male leaves first and travels the farthest. Other times a female leaves first. Wolves as young as 6 months have successfully left the pack, while others wait until they are 4–5 years old. The most common age for dispersal is 1–2 years. Dispersal depends on the amount and quality of food in the natal pack, the pack temperament and the personality of the youngsters. It works the same way for coyotes and foxes.

Dispersal usually occurs in fall and spring. Since breeding season is primarily in February, most young wolves become sexually mature in the fall. In addition, the pack starts to move around a lot more during fall to find food. Spring is also another favorable time to disperse. Tension in the pack during the denning period may contribute to the triggers that cause dispersal in spring.

The distance a young wolf disperses depends on age and individual preference and is highly variable. Some young never leave the natal territory and satellite around it for many years. Others make a beeline for the farthest reaches, up to 100 miles or more. In fact, satellite tracking of collared wolves has shown travel distances of hundreds of miles during the summer. Many other young wolves travel to new territories in between. The younger the wolf at dispersal, the shorter the distance it goes to find a new home. Older wolves tend to disperse farther distances.

Gray Wolf

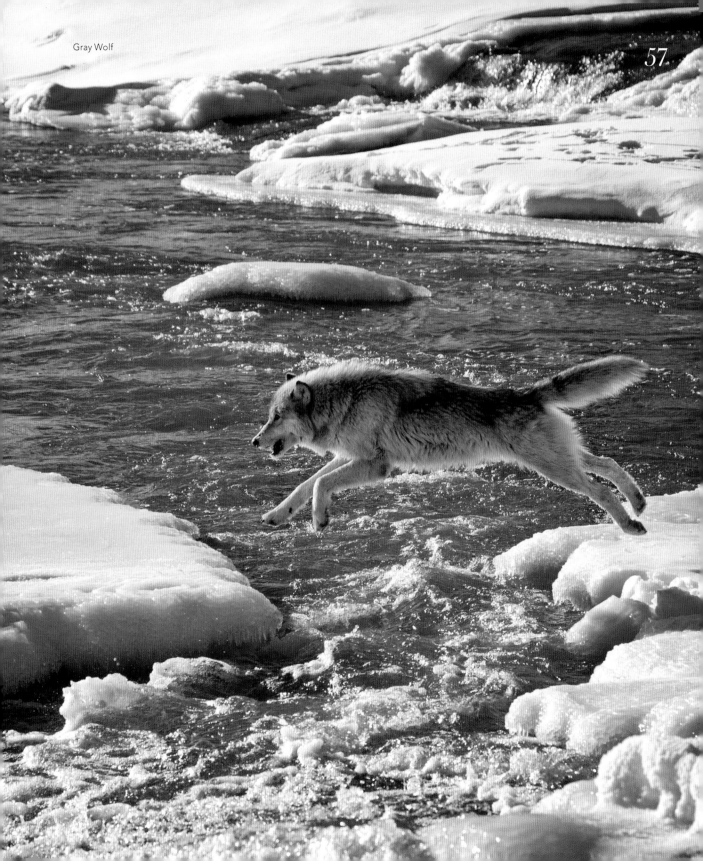

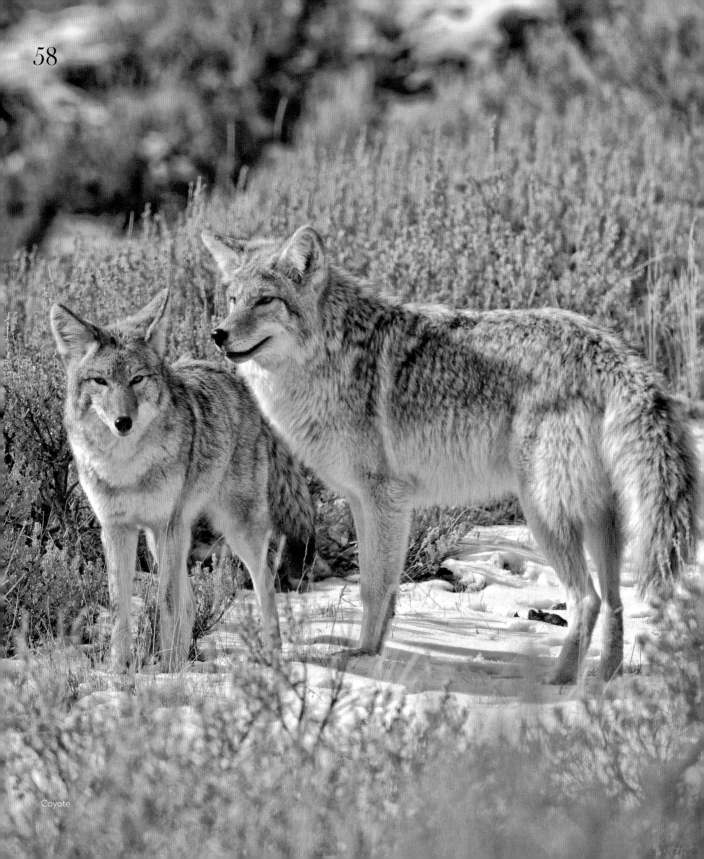

Coyote

Finding a mate

All dispersing wolves search for a mate, sufficient food and a new territory free of other wolves. A dispersing wolf is alone and has several choices. It can kill or usurp an established breeding wolf (sometimes its own parent) in a pack and take its place. This can be extremely dangerous, with the ultimate risk of death. For example, I witnessed a 4-hour fight in Yellowstone between two male wolves during breeding season. The newcomer won the battle, and the other lost his life.

A dispersing wolf can also gain permanent acceptance into a neighboring pack, or it may lure out a mate and disperse again. Hanging around the edge of a pack to draw away a prospective mate is another effective strategy. In other cases, a wolf may take up residency near an established pack, try to find another individual doing the same thing, and establish a pair bond along with a new territory.

Finding a mate is often a romantic happenstance. Two young wolves that have dispersed will just happen to meet while roaming around. Sometimes a wolf finds a mate by howling. Howling can be dangerous, however, because it advertises the wolf's location to all wolves in the area, friend and foe alike.

Young coyotes and foxes mature, disperse and look for a mate slightly earlier than wolves. Because the pack structure or family unit is less tightly knit in these animals, they often go without a mate and territory for a while, but eventually they will take a mate, establish a territory and reproduce.

Territory contrasts

Wolves are extremely territorial, and their territory size directly correlates to food availability and competition for prey. Wherever White-tailed Deer or other prey species are abundant and competition is limited, the home range to defend will be small. In other regions where food is scarce and neighboring packs are present, the territory tends to be much larger. Studies also show the higher the density of wolves, the smaller the territories.

Generally, the smaller the pack, the smaller the territory, and vice versa. Some of the smallest territories were documented in Minnesota, with one covering only 13 square miles. One of the largest territories was identified in Alaska's Denali National Park, spanning 1,693 square miles. Usually rivers, cliffs, mountains or other geographical landmarks serve as natural boundaries. Regardless of size and geography, holding and maintaining territory is a constant job that's never easy.

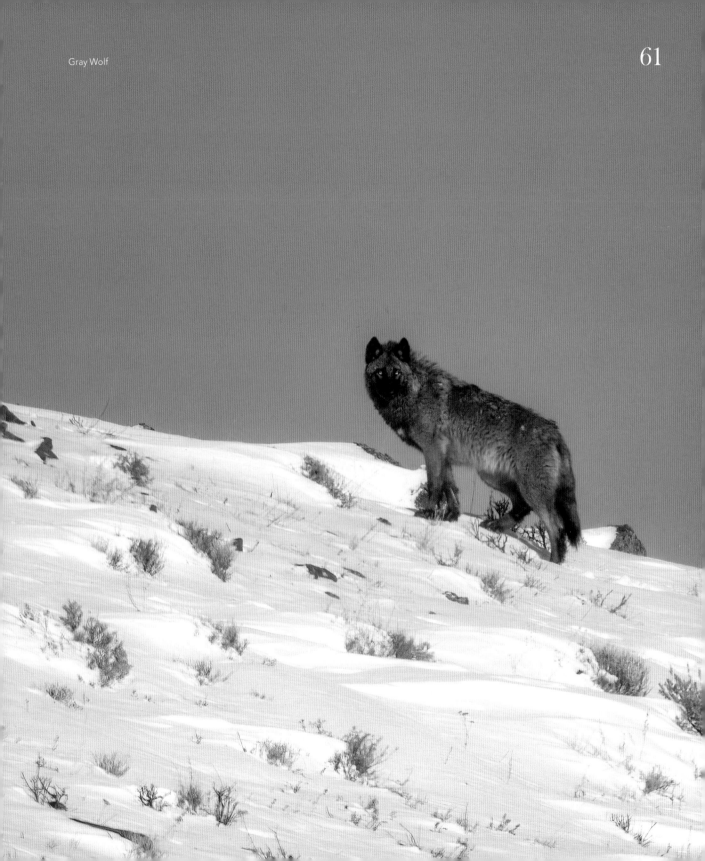

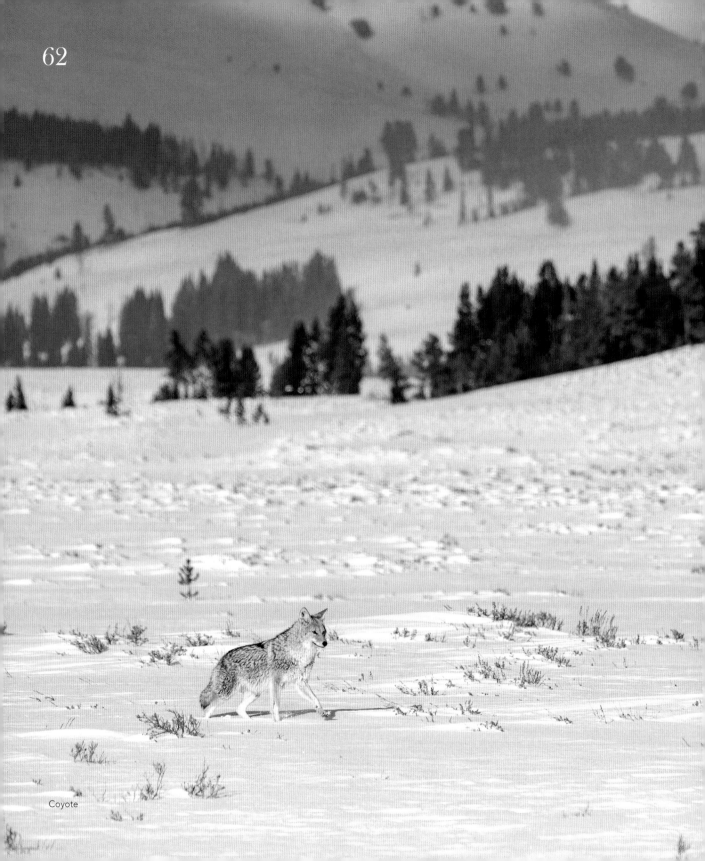

Coyote

Coyotes are known for roaming but not for defending territories. A coyote territory is usually occupied by two parents and any offspring that have not yet dispersed. Unlike wolves, coyotes feed on smaller prey, so they don't require large territories. The average territory of a coyote pack is 15–20 square miles, but it can be as small as 2 square miles.

In different parts of the United States and Canada, coyote ranges vary with the topography. In regions with wide-open spaces, territories are large. In more developed and populated areas in the eastern half of the United States, the ranges are much smaller. In fact, some coyotes in downtown Chicago have territories measured by street blocks.

Fox ranges are similar to those of coyotes. Foxes in the West, Alaska and Canada have large, expansive territories, unlike urban and suburban foxes, which have much smaller territories. Swift and Kit Foxes have small territories to match their diminutive size.

Roaming the home range

Wolves travel throughout their territories regularly each day. They have long legs and huge feet, which enable them to cross many miles regardless of weather—even deep snow won't stop them from moving daily. As they roam, they stop often to scent mark prominent structures. These spots can be a large outcrop of rocks or an old tree stump. They are also looking for interlopers or evidence of intrusions into the territory. Hunting usually occurs during this time also. Coyotes and foxes are no exception to these behaviors during travel.

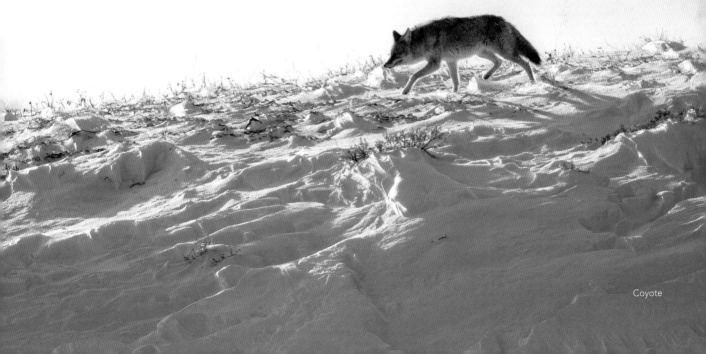

Coyote

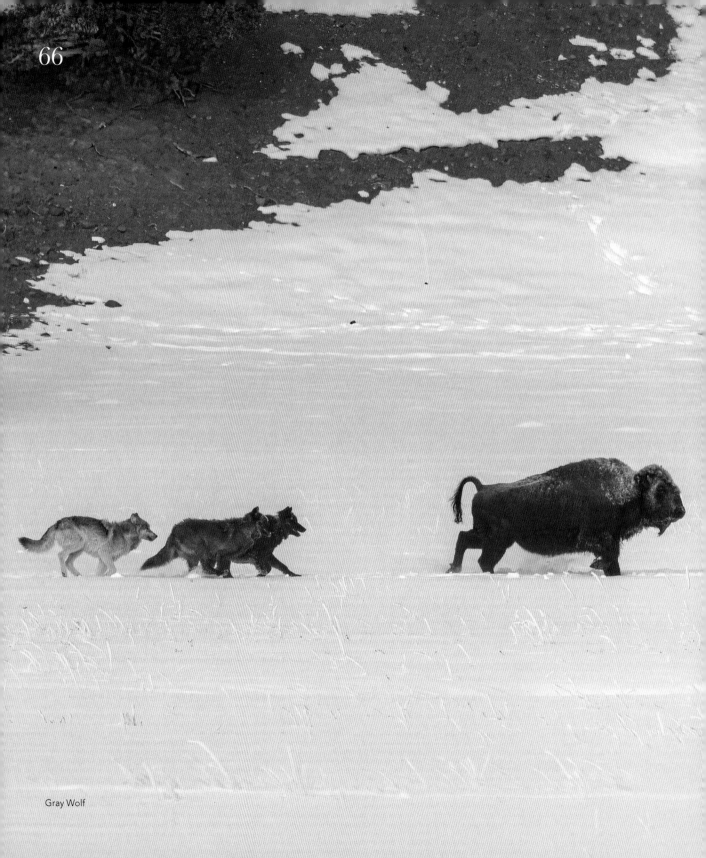

Gray Wolf

Following prey in winter

Wolves are so dependent upon large prey, they will move to follow it. For instance, White-tailed Deer often move during winter to low, moist areas where cedars and other evergreens provide shelter and food. Elk and bison trek down from high country to the shelter of valleys. Wolves will pursue prey in winter even if it means leaving their home range and remaining nomadic for the rest of the season. They return in spring when the prey base comes back into their territory.

Coyotes and foxes are not closely tied to large prey, so they rarely, if ever, leave their territories in pursuit of food. They often eke out a living in their own home range despite any population shifts in local rodents.

Scent marking

All canids have an extraordinary sense of smell and use it to communicate with others of their kind. Canids scent mark to designate their territory and possibly to convey sexual readiness. Males mark by standing and raising a hind leg during urination. Females mark with a half-sitting, flexed leg urination or by squatting.

The scent is carried in the urine and also in the feces (scat). Urine scent is part of the urine liquid. Scat scent is oily, and the anal glands deposit it onto the scat when it passes out of the body. Scratching on the ground with the forepaws or hind paws also distributes scent through small glands between the toes (interdigital). With each scratch a small amount of scent is deposited.

Scent posts are distributed every 100 feet or more. They are distributed throughout a wolf's territory, but most are left along the edges to mark boundaries. Scents are heavily used along main trails and especially at intersections within the territory.

Both wolves and coyotes leave twice as many markings along their territory edges as they do inside the boundaries. One study showed that a scent mark can remain active and constantly advertise intentions for up to 2–3 weeks if there is no rain or heavy dew in the mornings.

It is generally believed that when a wolf trespasses on another pack's territory, the intruder stops scent marking until it returns to its own range. It is also thought that the unfamiliar scent past a boundary is enough to intimidate an interloper.

Gray Wolf scat

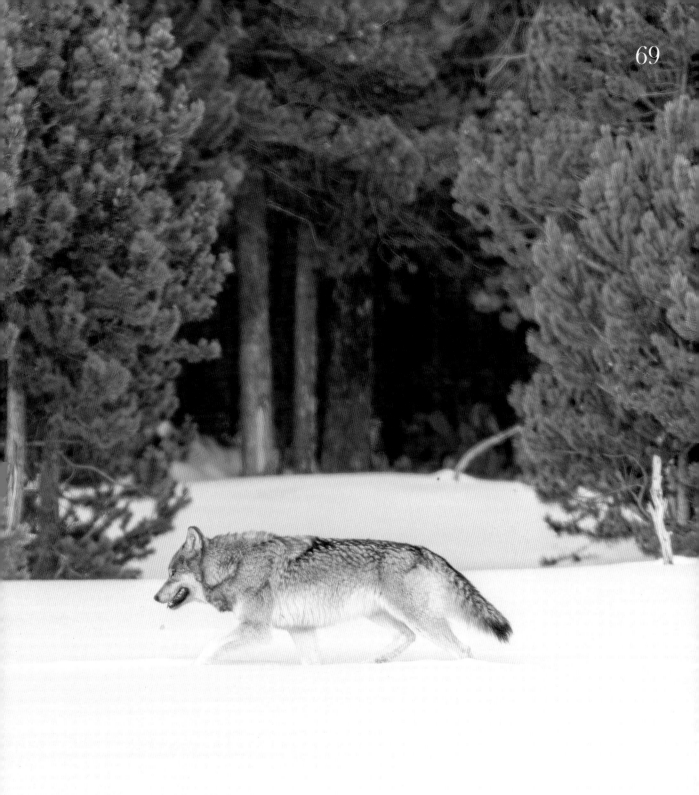

Gray Wolf

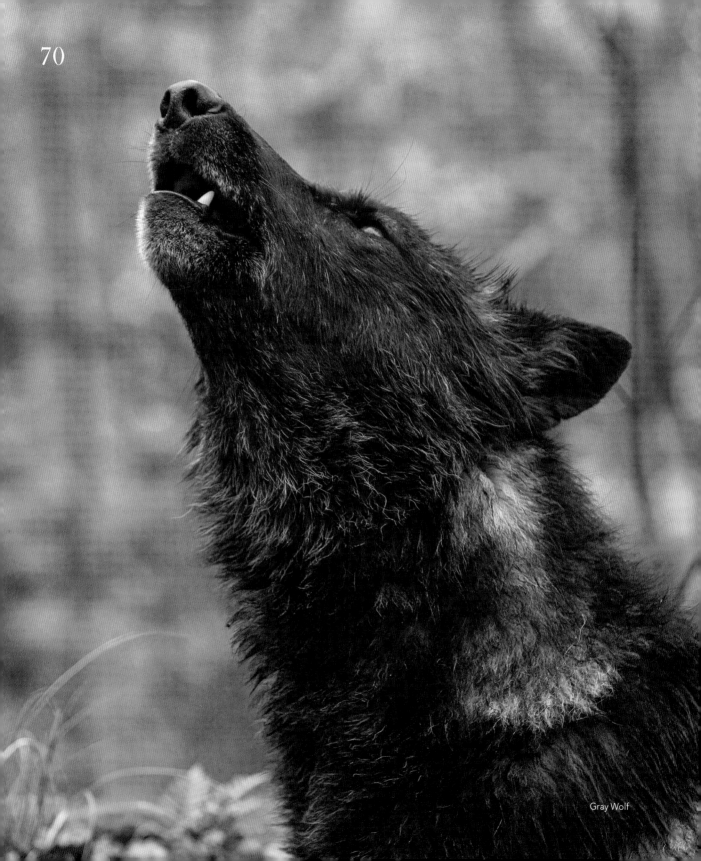

Gray Wolf

Howling to communicate

No other wolf behavior is as well known as the howl. A wolf's deep, long, mournful howl elicits goose bumps in most people—a single rising note, ending abruptly, just at the point the wolf is straining to get out the sound. Howling is mostly associated with loneliness, but that assumption is incorrect. It is also thought to have a connection with the moon, but this is also untrue. Howling peaks during breeding season in winter and is less frequent during summer.

Like scent marking, howling is used for communication. Scent marking communicates on a more personal level and in the immediate region. Howling complements scent marking because it carries across distances of many miles. It notifies neighboring wolves that a territory is occupied and the resident pack is willing to defend it. In forested regions where visibility is obscured, howling expresses information efficiently to other packs up to 6 miles away. In the American West and other open country, the sound can reach as far as 10 miles.

Gray Wolf

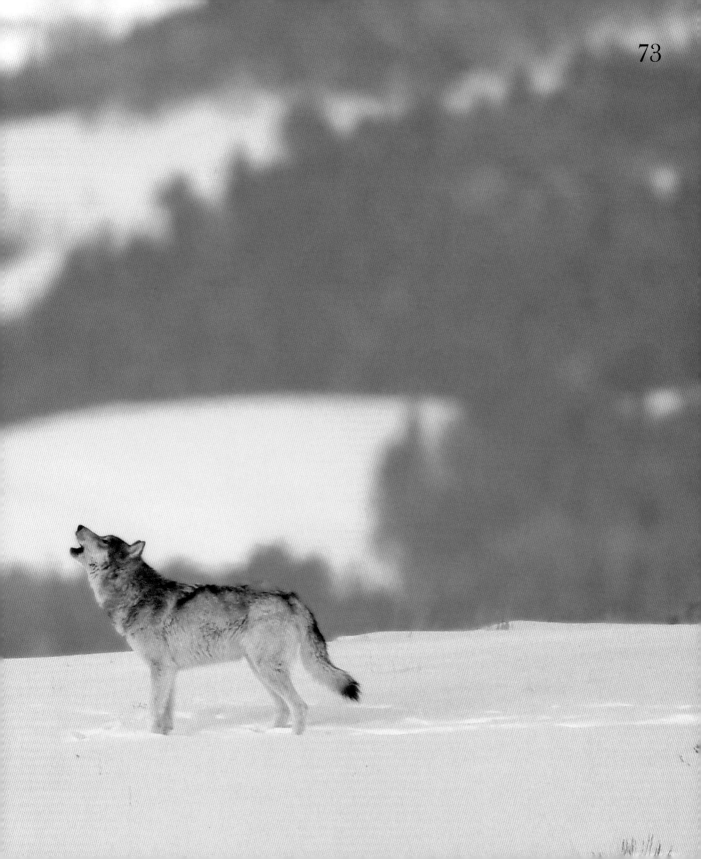

Gray Wolf

When wolves howl back and forth, it is almost always members of the same pack joining in the howl or answering other pack members. Howling to announce the possession of territory is almost never answered by neighboring packs.

Howling serves to bring a pack together after a separation. Often the alpha male or female will station itself at a predetermined place, called the rendezvous area, and start to howl. This is the gathering point for the rest of the pack, and members come in from all directions.

Wolves also howl to find absent members of the pack. While photographing wolves in Yellowstone, for example, I watched a pack howl to locate two missing members. When the individuals answered, the pack ran off to find them.

People can imitate wolf howls with a great degree of accuracy, and wolves within hearing range will answer them—which is unusual because wolves usually don't answer other wolves that are not in their pack. They may even come to investigate. Wolves can hear human howls from a distance of up to 2 miles. They have an uncanny ability to pinpoint the source of the sound and often approach to seek it out, much to the concern of people.

Howling is not the only sound wolves make to express themselves. Growling is also a common vocalization. Wolf pups growl during playtime, and adults growl or snarl to show displeasure.

Incidentally, wolves in the wild don't bark like dogs. A rare single bark, more accurately described as a "woof" sound, has been reported only in captive packs and is used as an aggressive guarding response.

A coyote howl is much different from that of a wolf. Coyotes begin with a series of yips, which turn into high-pitched shrieking calls. The sounds coyotes make are more like dog yaps and high-pitched cries, unlike the long, throaty, somber howls of wolves.

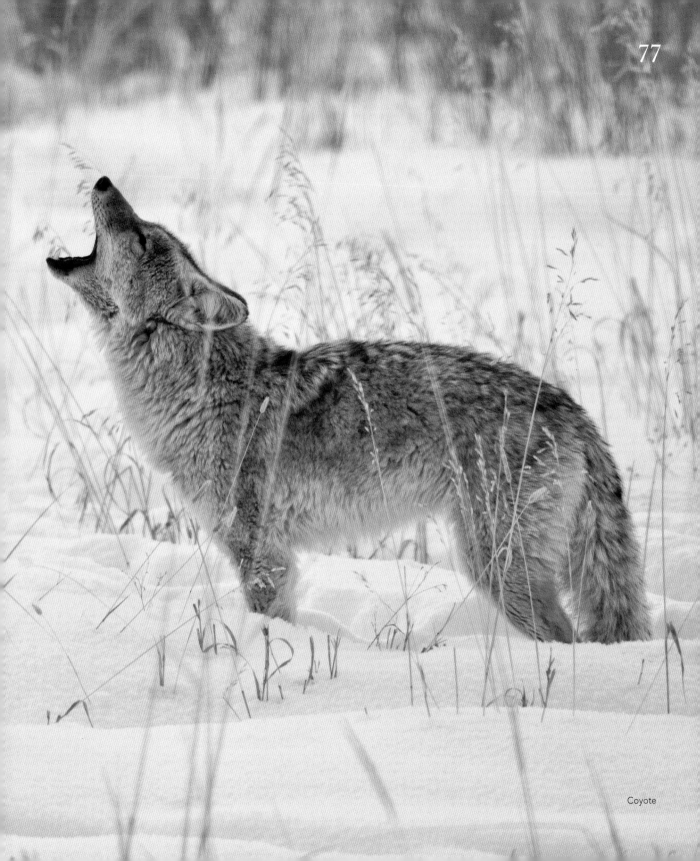

Coyote

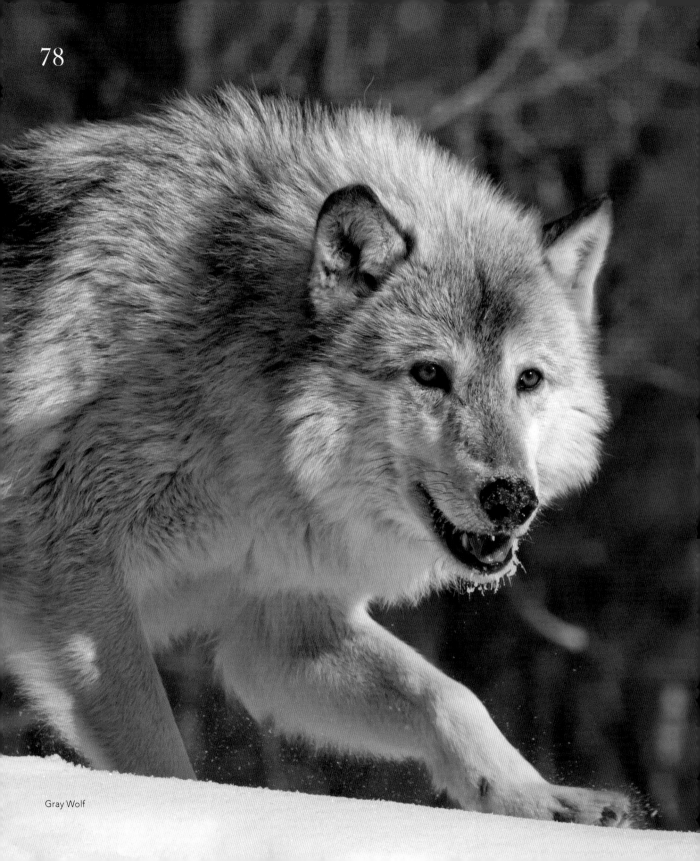

Gray Wolf

Silent expressions

In the same ways that scent marking and howling communicate, so does facial expression. Any dog owner can confirm that a dog has many facial expressions. It's easy to know when a pet dog is happy—head is up, ears are forward, eyes are wide-open and lips are relaxed in a smile. It's also easy to recognize a threatened dog—head is down, ears are back, eyes are narrowed and lips are pulled back to reveal teeth. Facial expression in wolves, coyotes and foxes is the same. Their silent expressions speak volumes to their mates and families and also to any intruders.

Tail language

A wolf's tail is one of the most visually expressive parts of the animal. Its position and movement can convey happiness, aggression, submission, dominance and much more. Most people know that a dog's wagging tail is a show of friendliness. In contrast, stiff tail movements or quick flicks of the tail tip indicate a heightened state of awareness. Like human language, tail communication is complicated and takes a long time to learn and understand. Grouping into high, neutral and low postural attitudes makes it easier. Keep in mind that there are many positions in between that send slightly different messages.

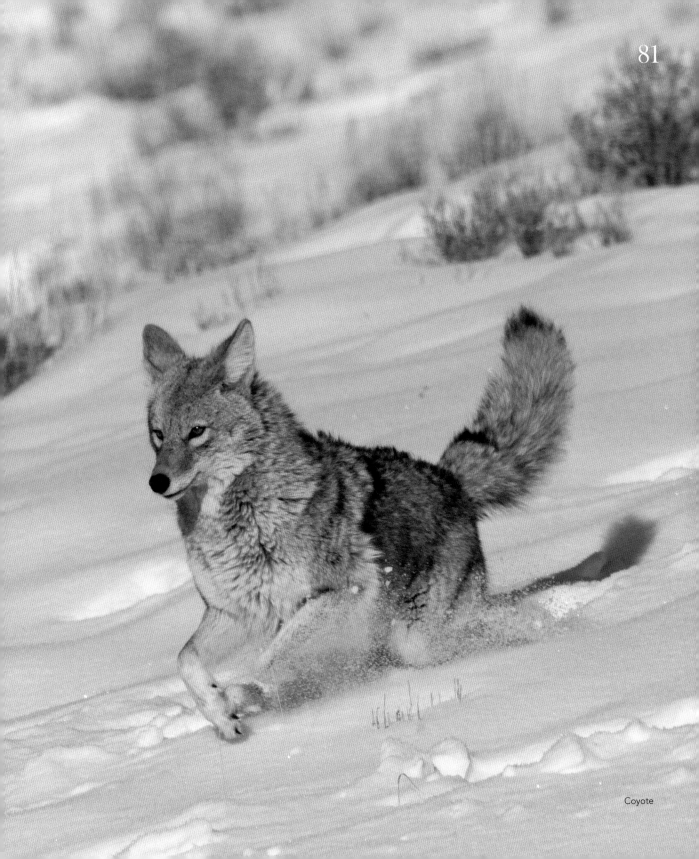

Coyote

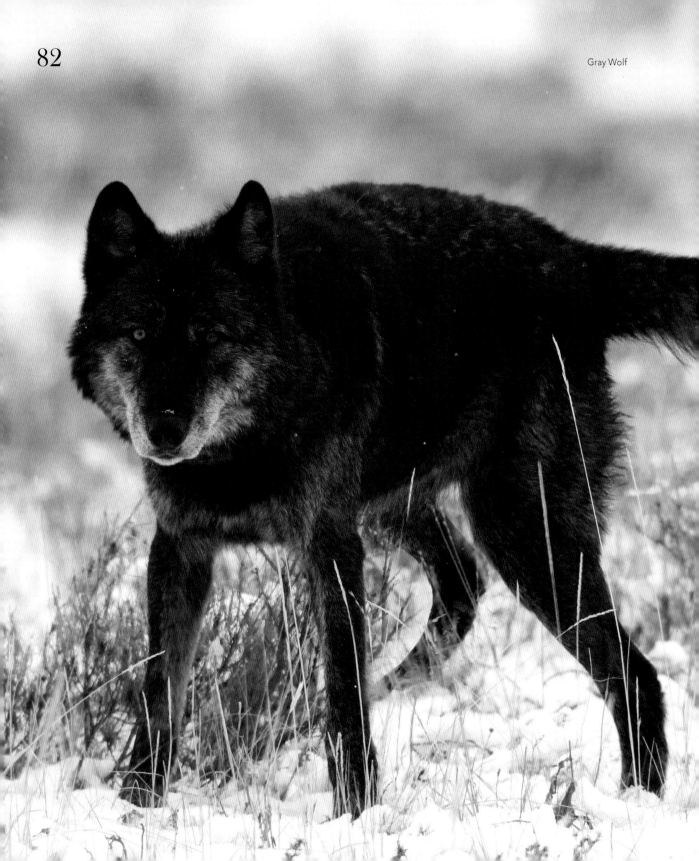

High and low tail positions are directly related to head and ear positions and facial expressions. They convey rank and relationship to pack members and are the basics of communication whenever pack members interact.

A high tail position shows self-assertion during social interactions—but it can also send a threatening message. A high tail with wagging afterward means intimidation.

A relaxed tail in a slightly lowered, neutral position suggests routine, nonthreatening social conditions. Turn up the tip of a lowered tail and now it means, "Not quite certain—I'm watching you."

A low tail tucked between the hind legs is a defensive posture and indicates the individual is being threatened. Usually the tighter the tuck, the more submissive and stronger the inhibition.

Conflict response

Wolves define their territories well with much scent marking and howling to avoid dangerous interactions with other packs. Nearly all pack-to-pack conflicts are due to individual trespassers or a trespassing pack, resulting in significant injuries and sometimes death. Trespassing incidents are almost always because of lack of food. If a prey base moves or available food is depleted, a pack will take desperate measures. In most cases, the results are fights so brutal that one or more pack members die from the injuries.

In Yellowstone during the winter of 2009, I followed a pack of starving wolves into a neighboring pack's territory where they attempted to feed on the remains of a bison carcass. When the resident wolves discovered them, a huge fight broke out. Unfortunately, the alpha female of the trespassing pack became so severely injured that she didn't even survive the night.

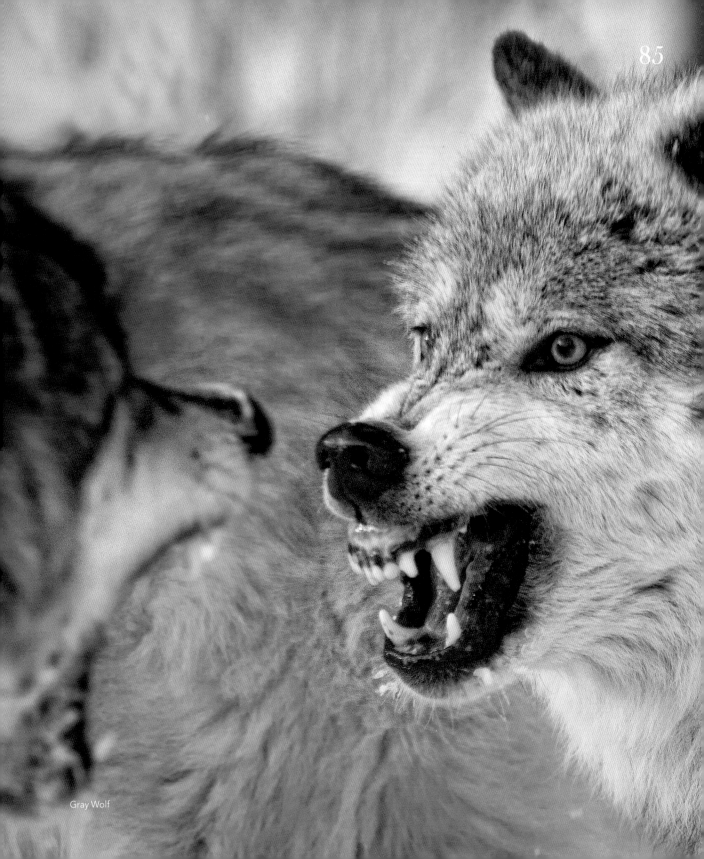

Gray Wolf

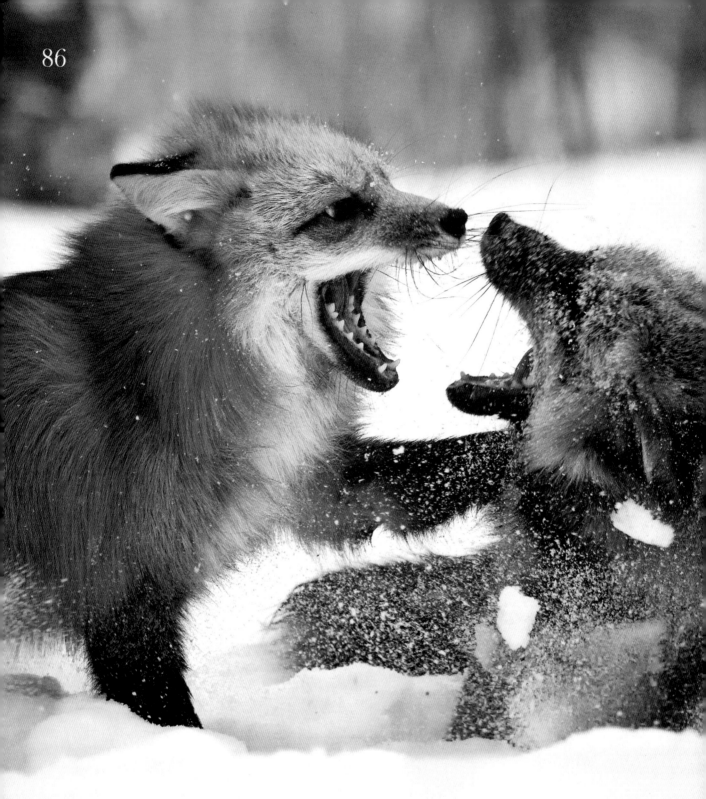

Red Fox

Coyotes also experience trespassing issues and con-
flicts but not to the extent of wolves. Their conflict often
occurs when more than one individual turns up at a wolf
food source such as a leftover kill. While one coyote
is feeding, a second coyote will arrive (they've usually
already seen each other from afar). Upon approach,
they hold their tails down tightly between their legs and
arch their backs, with their neck and back hair standing
on end. Often they turn sideways to appear even larger.
Just before making contact, they lower their heads and
open their mouths, showing their teeth, called a gape.
Coyote fights, however, are more like squabbles. After
much posturing and vocalization, one usually backs
away and leaves, trotting off.

Foxes tend to avoid each other, but when two encoun-
ter it often results in a boxing match. As soon as an
intruder is spotted, the resident fox engages the
interloper. Quickly they run toward each other and grab
one another with their front legs while standing on their
back legs—much like wrestlers. They open their mouths
wide to show their teeth, getting as close as nose to
nose. Both are very vocal now, with much pushing and
shoving and a fair amount of biting. This lasts from 30
seconds to 1-2 minutes. During this time something is
communicated and one usually turns and runs, ending
the conflict. In other cases, the fight continues.

Scent rolling

Anyone who has a pet dog is no doubt familiar with the odd behavior of scent rolling. This is the process in which a canid, such as a wolf, coyote or fox, finds something odiferous and rolls on it, rubbing the scent all over its body. First it lowers its head and shoulders onto the stinking object, and then it starts to roll, making sure its chin, shoulders and back contact the smelly object.

No one knows why canids scent roll, but plausible theories abound. It might be they are familiarizing themselves with a new odor, or they are bringing the scent back to the rest of the pack to communicate with other pack members. Or they could be strongly attracted to the smell. Perhaps they are attempting to conceal their own scent with one more powerful. Maybe the odor makes a male more attractive to a female. It may even be a combination of these ideas, ranging from hiding to overt communication. What's your best guess?

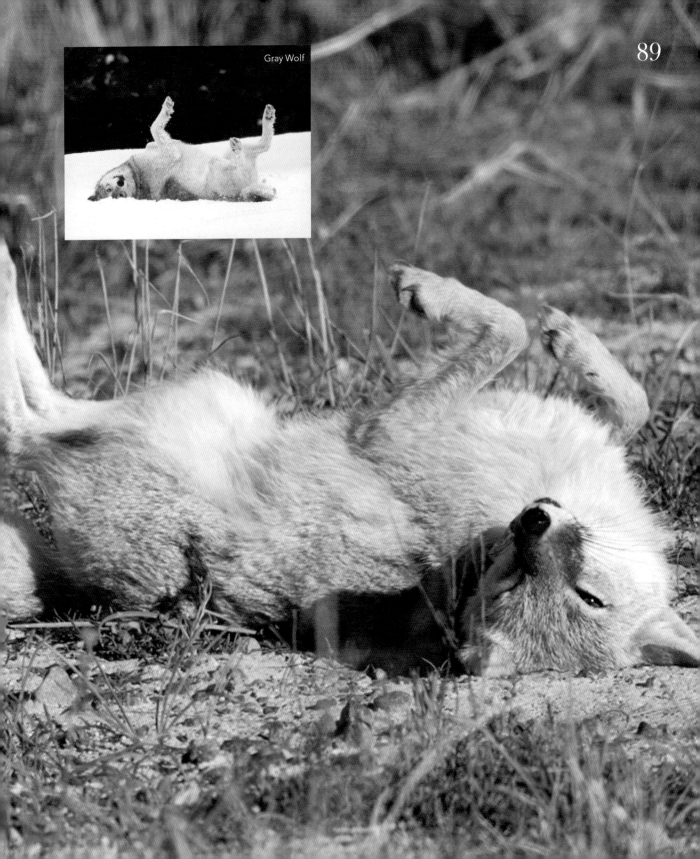

Gray Wolf

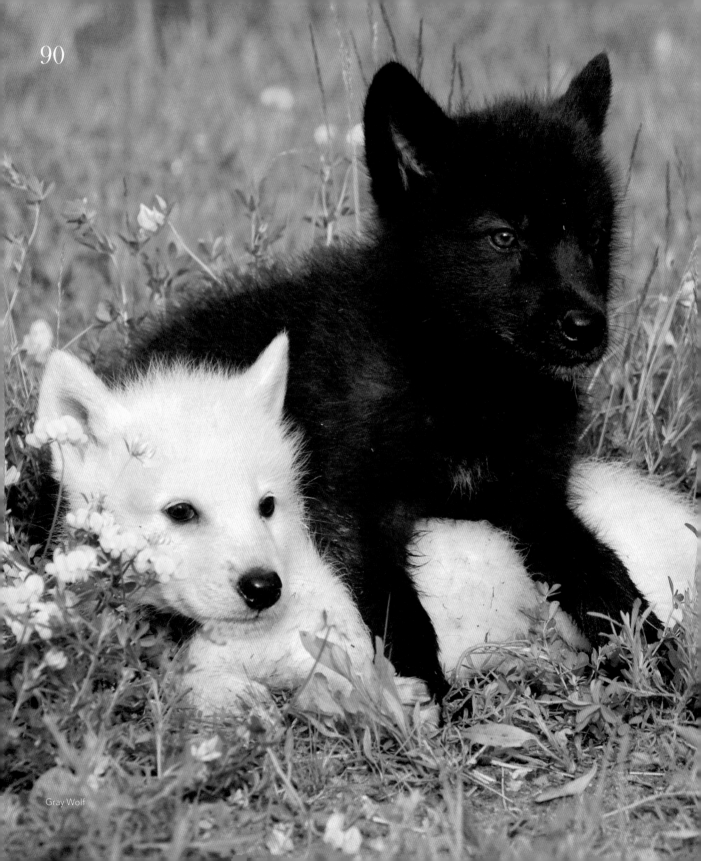

Gray Wolf

Wolf and dog breeding

Since the wolf is the ancestor of the domestic dog, it seems reasonable that wolves and dogs still hybridize. In the field, however, this occurrence is not common. Because it is in the wolf's nature to eliminate the competition, most encounters in the wild of wolf and dog result in the dog's death.

The deliberate breeding of wolf and dog occurs under human control, as it has for thousands of years. Early North American Indigenous peoples would hybridize their dogs with wolves, and there are many other historical records of this activity. Today, hybridization of wolves and dogs produces large, powerful animals that don't make good family pets. This kind of meddling with nature never has a good outcome. Breeding and selling any hybrid of wolf and dog should be strongly discouraged.

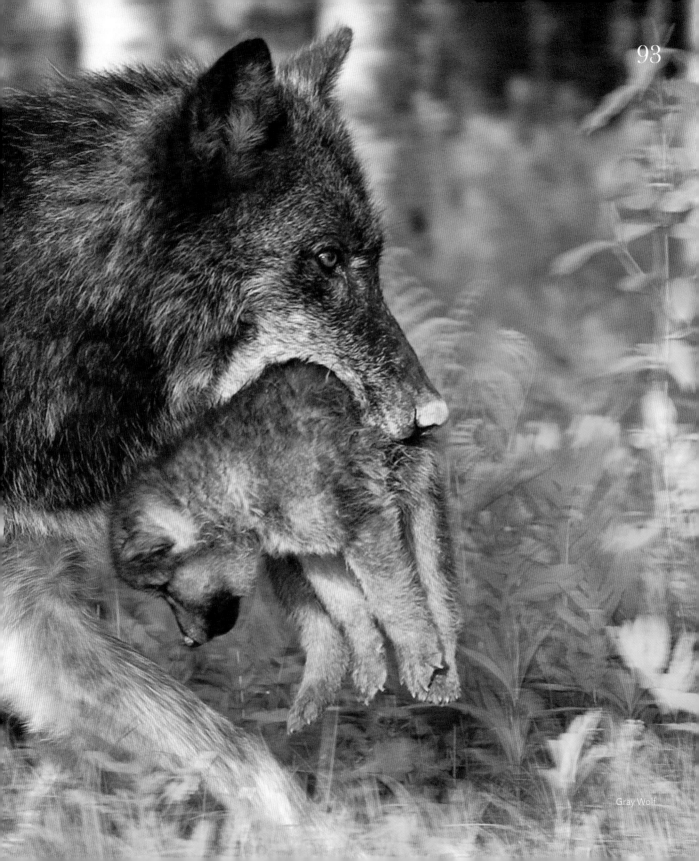

Gray Wolf

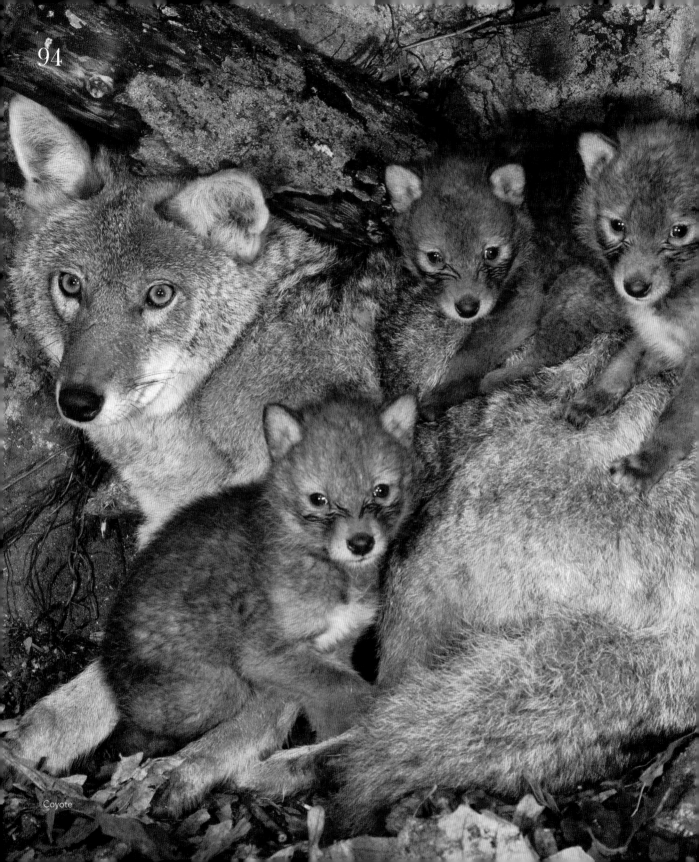

Coyote

Wolf and coyote hybrids

Wolves and coyotes share nearly their entire DNA. They look so similar that most people confuse them, even though they are different species. While some think wolves and coyotes regularly hybridize, the actual relationship between them is not good. In fact, wolves often chase and kill coyotes to reduce the local competition.

There is body form (morphological) and DNA evidence that some wolf populations have bred with coyotes. In southeastern Ontario, southern Quebec and parts of U.S. states bordering these provinces, there are coyotes that look suspiciously like wolves, only much smaller. I saw pictures of these animals and they look rather convincing. However, there isn't any confirmation that hybridization has spread beyond this area. Most interesting, the hybridizing that did occur seems to have been a direct result of lower populations during the time that the governments were trying to eliminate the wolf.

Wolves in Alaska and the West are 100 percent wolf, with no DNA evidence of hybridization. In the western Great Lakes, the genetic makeup is about 85-90 percent wolf and 10-15 percent coyote, as some geneticists contend. The Red Wolf in North Carolina is only 24 percent wolf and 76 percent coyote. There is no indication of any wolf and fox species hybridizing, and there is very little hybridizing between coyotes and domestic dogs.

Regional diversity

Close contact with the environment influences the physical attributes of wolves, coyotes and foxes and results in significant regional differences. For example, wolves in the Arctic are larger, often with white fur. The larger the animal, the greater the body mass and the easier it is to retain body heat. White fur allows Arctic Wolves, Polar Bears and other species to blend well into snowy environments. In addition, a new theory suggests that white fur is thicker, which enables more air to be trapped between the unpigmented hairs, keeping the animals warmer. Because sunlight is so weak in the far north, it is also possible that animals don't need the protection from ultraviolet light provided by the dark pigments, which normally color fur.

As the ecosystem changes southward, so does the outward appearance of wolves. They become slightly smaller, and their fur becomes darker and less dense. The Mexican Wolf (*Canis lupus baileyi*), a Gray Wolf subspecies, is the smallest wolf in North America. Its fur is a rusty color, matching the arid, sandy regions where it lives. The Red Wolf of the Southeast is also small, but it has darker, richer fur. The wolves in Yellowstone and surrounding areas are a combination of gray and black, with more black wolves than gray. Wolves in Minnesota and Wisconsin tend to be mostly gray, with a scattering of black individuals.

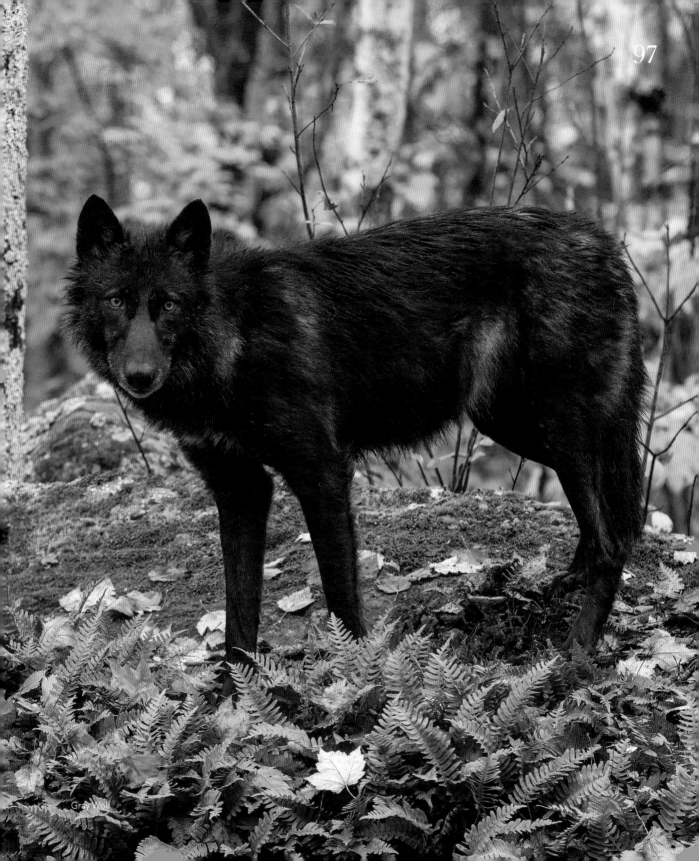

Gray Wolf

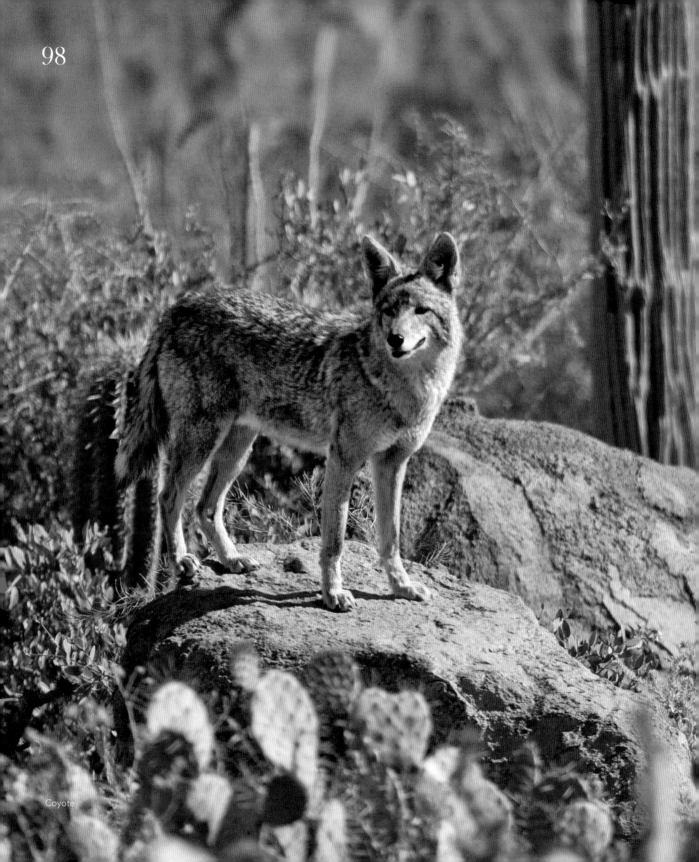

Coyote

Coyotes don't change much from region to region, with a few exceptions. Coyotes of the West and North tend to be slightly larger than those in the desert Southwest. While wolves range from all black to mixed shades to completely white, coyotes have little color variation and are usually some shade of gray or tan. Fur density corresponds to the climate of residence. Like wolves, coyotes in northern states tend to have thicker fur than those in southwestern states such as Arizona.

Eastern coyotes are relatively new. A slow, steady expansion of the range eastward has brought coyotes into every eastern state. These animals are standard in size and color.

Coyotes of southeastern Canada show remarkable variability. As you may recall, this is the region where some hybridization between wolves and coyotes has apparently occurred. Coyotes here tend to be larger and darker, appearing more like wolves, with smaller ears, wider heads and stocky bodies.

Foxes show all sorts of variability, not only from region to region, but also from individual to individual. There seems to be only slight regional correlation to color. For instance, Red Foxes on Isle Royale in Lake Superior tend to be very dark to nearly black. This is unlike other Red Foxes, which can be red to orange with gradients of color intensity. Many others are nearly gray or tan, and blond or yellowish foxes are not uncommon. No matter the color, the tip of a Red Fox's tail is always white. Gray Foxes have black-tipped tails, like wolves and coyotes.

Summer and winter coats

In many regions, winter is cold and snowy. Wolves spend all their time outside during this season, wearing heavy fur coats. The same is true for coyotes and foxes. Beginning in late summer and early fall, they start to grow dense undercoats. Over a month or more, the undercoats slowly fill in, adding up to one-third of total fur. A thick undercoat creates a bulky appearance, but it keeps the animals warm and dry. Even Red and Mexican Wolves, which live in relatively warm regions, have thick undercoats in winter.

In addition to the undercoat, all canids have guard hairs, which make up the outermost layer of fur. Guard hairs are as long as 3–4 inches and give the animals their color and shape. They also help to shed water and are the first line of defense against cold.

To keep the feet warm and help protect against sharp ice, even the foot pads have extra fur during winter. Occasionally, however, the canids need to clear away the ice that accumulates between their toes.

When the weather warms in spring, all canids shed their winter coats. The fur comes out in clumps and patches, making them look ragged and messy, with the entire process taking a little over a month.

By summer, their coats are short and sleek. At this time the animals appear much smaller and lightweight compared with their more substantial form in winter.

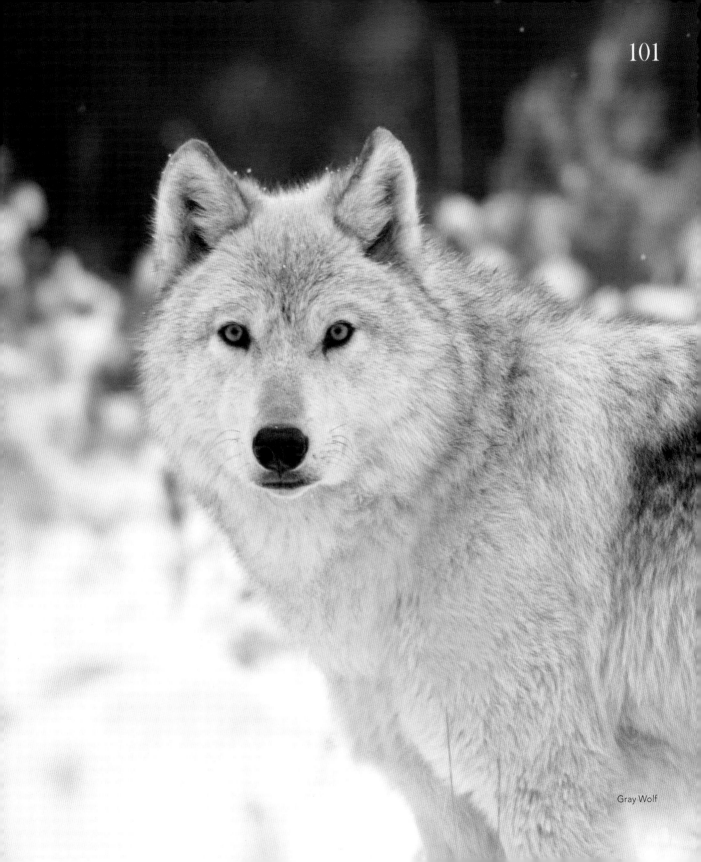

Gray Wolf

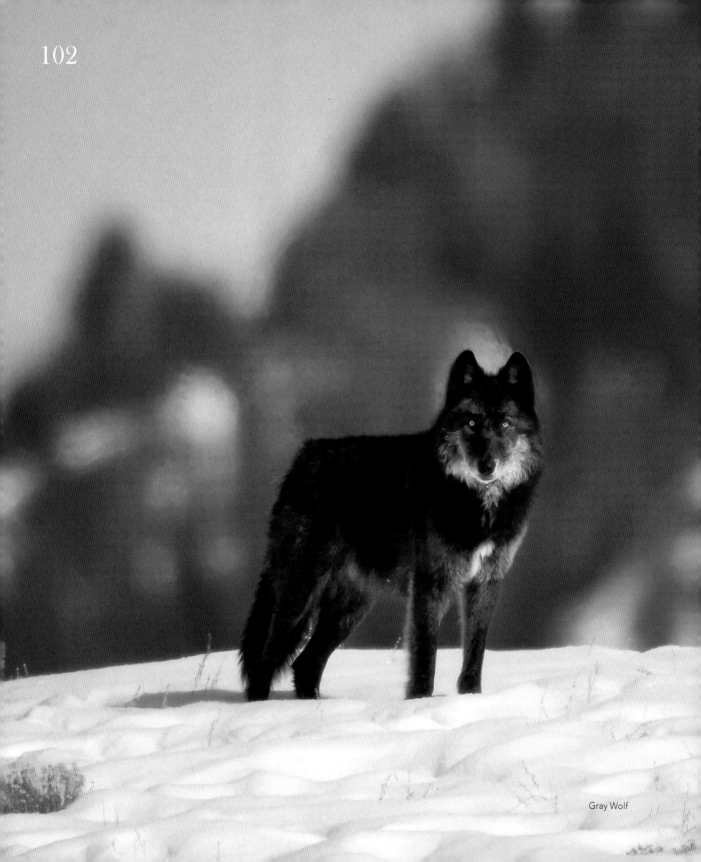

Gray Wolf

Graying gracefully

Just like people, wolves become gray as they age. Many wolves have white jowls in their youth. As a wolf ages, the region around the jowls begins to turn gray. Afterward the entire face starts graying, and the rest of the body follows. This is most noticeable in black wolves. By the time an all-black wolf reaches its elderly years, it is all gray. In other wolves the color change is very obvious in the face, but overall it is much less noticeable. The same graying of the jowls and face can also be seen in our aging domestic dogs.

Skull and jaws

A wolf skull tends to be extra large and blocky. The larger skull provides room to anchor extra jaw muscles, which enable a more powerful bite. Wolves have tremendous jaw pressure (double that of a German Shepherd or other large domestic dog) and can exert as much as 1,500 pounds of pressure per square inch! This incredible pressure is essential for initially killing prey and crushing bones while chewing.

Unlike wolf skulls, the skulls of coyotes and foxes are smaller and narrower, with much less surface area for additional muscle attachment. Coyotes and foxes tend to feed on voles, mice and other small prey, which they often swallow whole. While extremely large and powerful jaws are less important, they still need a killing bite and sharp teeth.

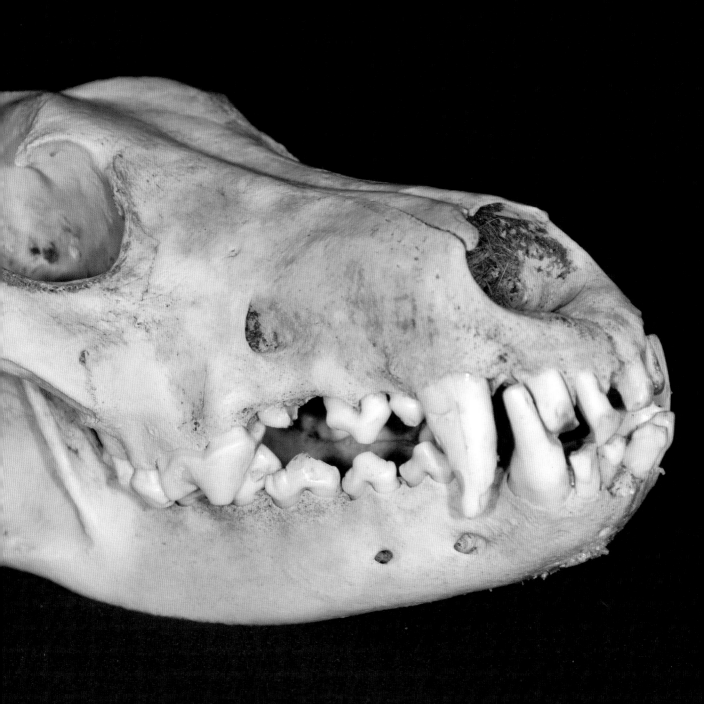

Gray Wolf

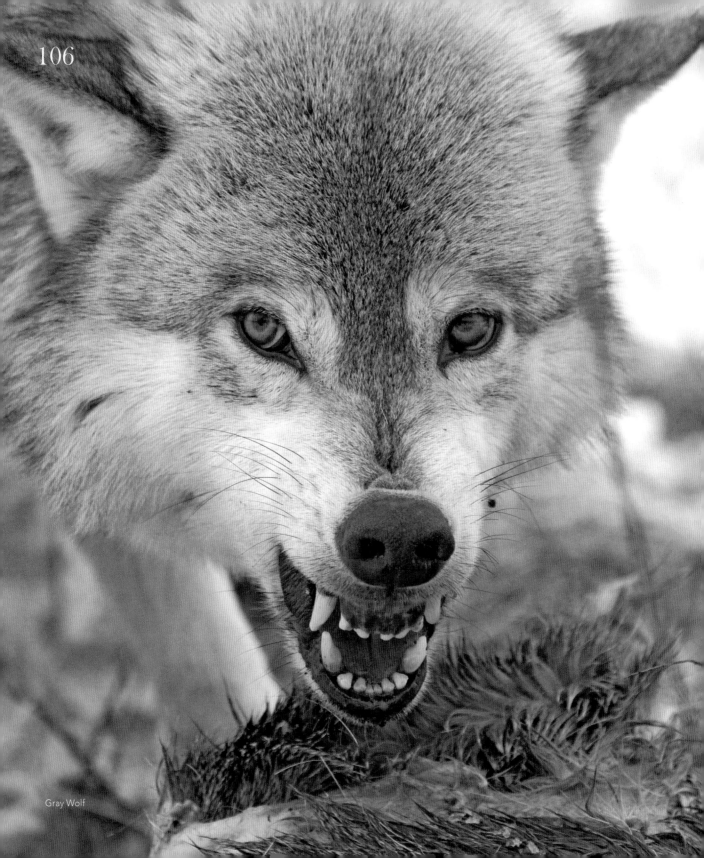

Gray Wolf

Canid teeth

Wolves have 42 teeth—4 upper molars, 6 lower molars and 16 other teeth in each jaw that include 8 premolars, 6 incisors and 2 canines. The largest teeth are the canines, sometimes called fangs. The canines can be as long as 2¼ inches and are used to grab and hold prey. Since all canids are mainly meat eaters (carnivorous), most of their teeth are designed to cut or slice flesh. Only the molars are for grinding. These get minimal use.

When wolves are feeding, it's usually a fast and furious frenzy. They quickly bite, tear and swallow—bones and all. It is easy for wolves to slice off large hunks of meat with their sharp teeth and swallow them whole. They will also bite cleanly through a deer rib, grind it with a few chomps and swallow. Wolves consume so much meat that their bellies are visibly swollen and sagging after feeding. Overeating is necessary for those with pups to feed at the den because they carry the extra food back in their bellies to regurgitate.

Excellent sense of smell

All canids have an excellent ability to smell. It is the most powerful of all their senses. Wolves, coyotes and foxes rely on smell more than any other sense for communicating, finding food and gathering information about mates or other canids. In these animals, the sense of smell is estimated to be about 100 times better than in humans. In fact, they can smell odors that people can't even imagine. Wolves also have a better sense of smell than domestic dogs.

A wolf's nose has about 5 times more surface area than that of an adult human. The long, narrow snout creates additional area for the extra olfactory receptors. The enhanced ability to smell allows wolves to catch the scent of prey up to a mile away, providing the wind is blowing in their direction. This gives them the slight advantage needed for a successful hunt. Some studies suggest that they can detect the odor of an animal or human for up to 3 days after the individual has left the area. Of course, this amazing ability to smell also allows them to read scent marks left by other members of their pack or neighboring packs. Odor also tells the males when a female is ready for mating. For wolves, odors may convey information such as gender, individual identity, breeding condition, social status, age, physical condition and even the diet of the animal that left the scent.

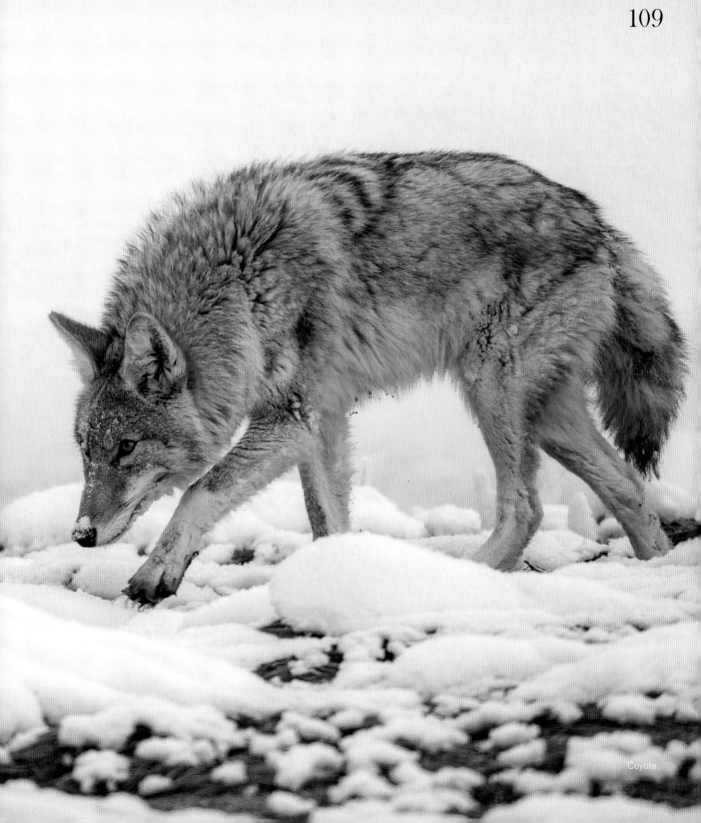

Coyote

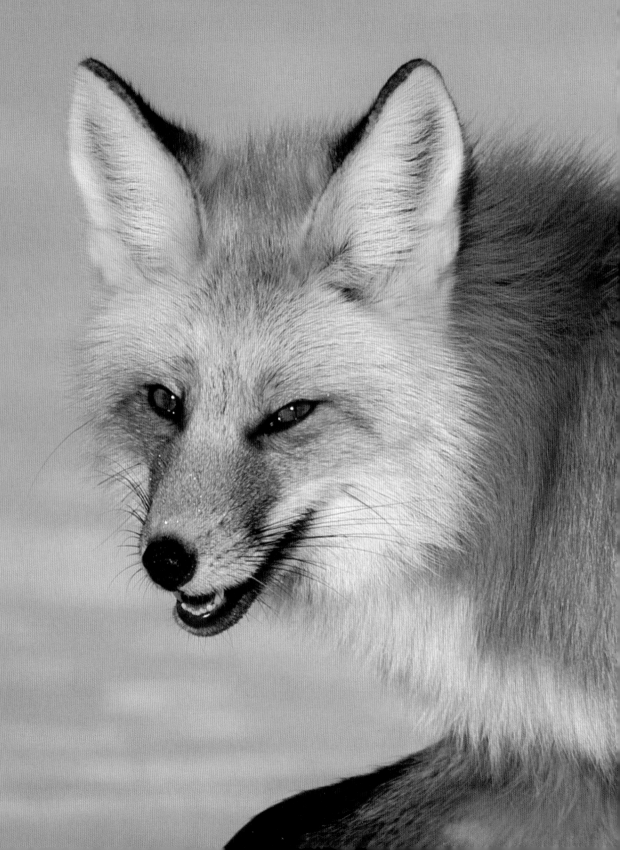

Red Fox

Ear appeal

One of the first things you'll notice about a wolf, coyote or fox is its large ears (pinnae). The ears appear slightly smaller on a wolf, but that's only because its head is so large. Coyote and fox ears look very large because their heads are relatively small.

Generally, the ears of these canids are large and extremely functional. They stand straight up nearly all the time except when the animal is showing aggression or fighting. They also swivel independently to focus on sounds at each side and in back.

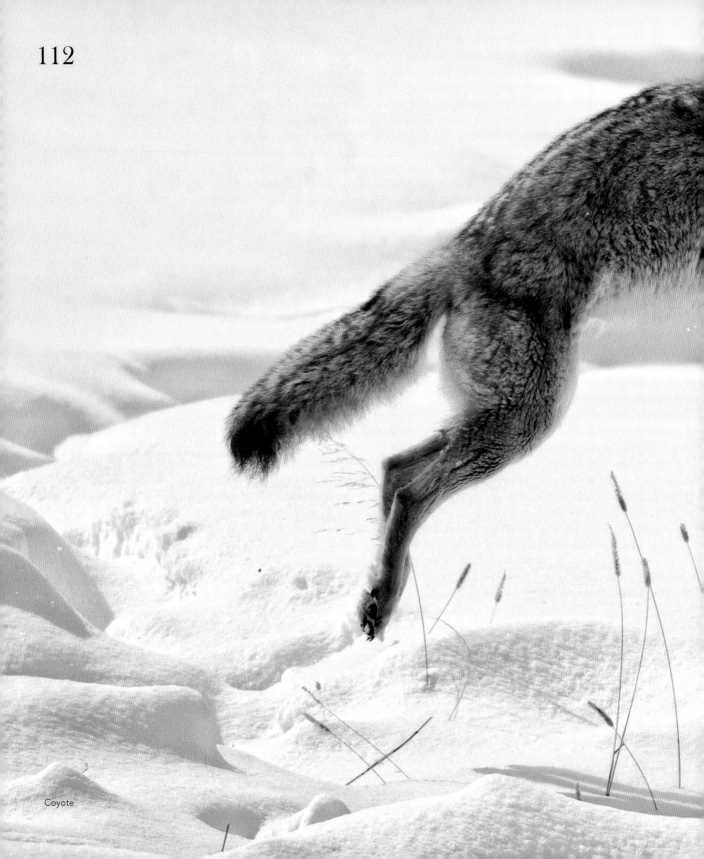

Coyote

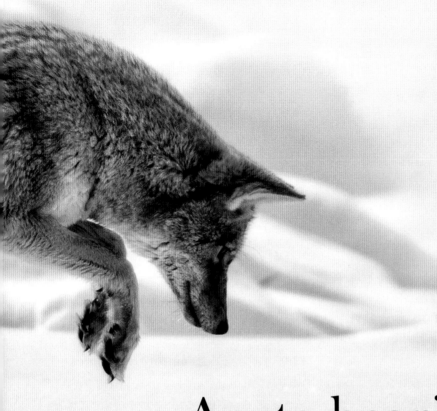

Acute hearing

After smell, hearing is the next most important sense. Wolves are able to hear the howl of a pack mate up to 6 miles away in a forested region and as far as 10 miles out in open habitat.

Coyotes and foxes also have acute hearing. They can pinpoint a vole or other small mammal under several feet of snow and pounce on it with amazing accuracy. They will cock their head back and forth, focusing each ear on the sound. This process helps them identify both the horizontal and vertical positions of the noise. When these are established, they coil up and pounce on the unsuspecting critter.

The sight field

Much of what is known about the eyesight of wolves, coyotes and foxes is based on domestic dog sight—which is not like our sight. In people, there is a small depression in the back of each eye where all incoming light is focused. This region, called the fovea centralis, gives us the ability to focus sharply on objects in the far distance. Like domestic dogs, all wolves, coyotes and foxes lack this central focusing spot, so their clear vision in front is limited to about 100 feet. Also, their eyes are positioned toward the front of their heads, giving them three-dimensional (stereoscopic) vision. But even though their field of vision is about 180-200 degrees (which is slightly greater than in people), just a small portion of it is stereoscopic since their field of vision is directed more laterally. Because of the limited stereoscopy, these animals see as well as we do when an object is near or not too far away, but at longer distances their vision is diminished.

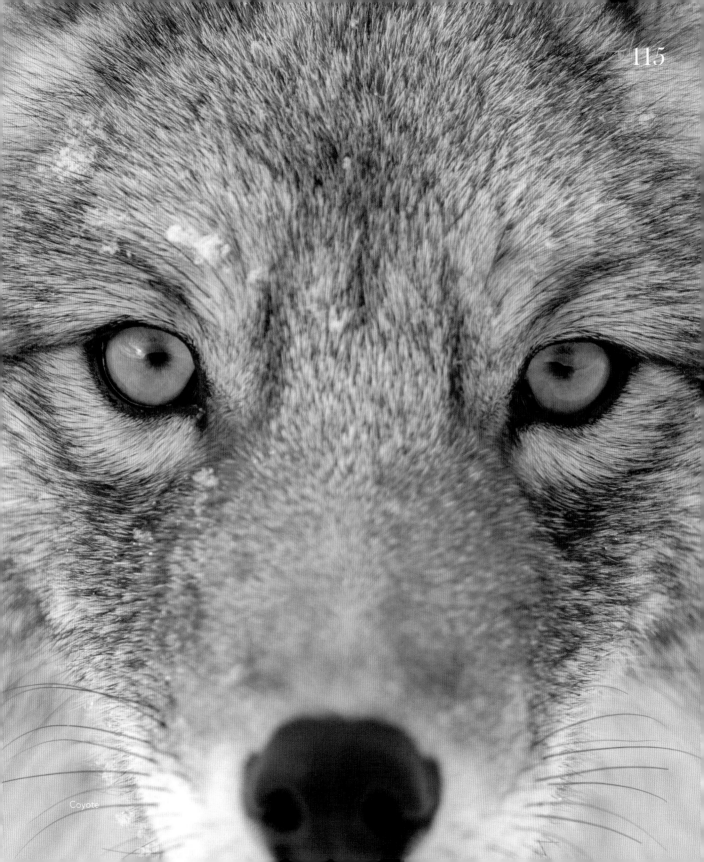

Coyote

Red Fox

Color and splatter vision

The ability to see in color lies in the density and distribution of the rods and cones that line the back of the eye. In people, cones are densely packed into the foveae, but there are no rods. This provides vision that works best in daylight conditions (enabling excellent color discrimination) and also dominates the center of the visual field. In place of foveae, canids have a general region of focus at the back of each eye that is up to 4 times denser in rods and cones. This provides superior nocturnal sight and better splatter vision, which doesn't concentrate on a single object in front—thus, they have excellent peripheral sight. With splatter vision, their ability to see movement is greatly enhanced, allowing them to notice even the slightest movement at fairly long distances.

It is generally agreed that wolves have some ability to see a few shades of color, such as blue and green, in addition to black and white. The amount and congregation of rods and cones in the eyes of wolves, coyotes and foxes suggest that these animals can see some color but not in the same way as people. They lose color vision at night, but they can see far better than we do in low light, giving them the edge needed for nocturnal hunting.

Long, strong legs

When you first see a wolf, its long legs are one of the most obvious features you'll notice. Most wolves have long, powerful legs that help propel them through deep snow or chase down prey during summer.

Coyotes and foxes also have long legs compared with their bodies but not as much as wolves. Both are well known for traveling long distances, and their long, strong legs make the job easy.

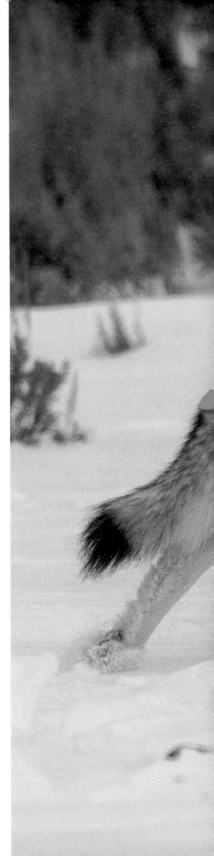

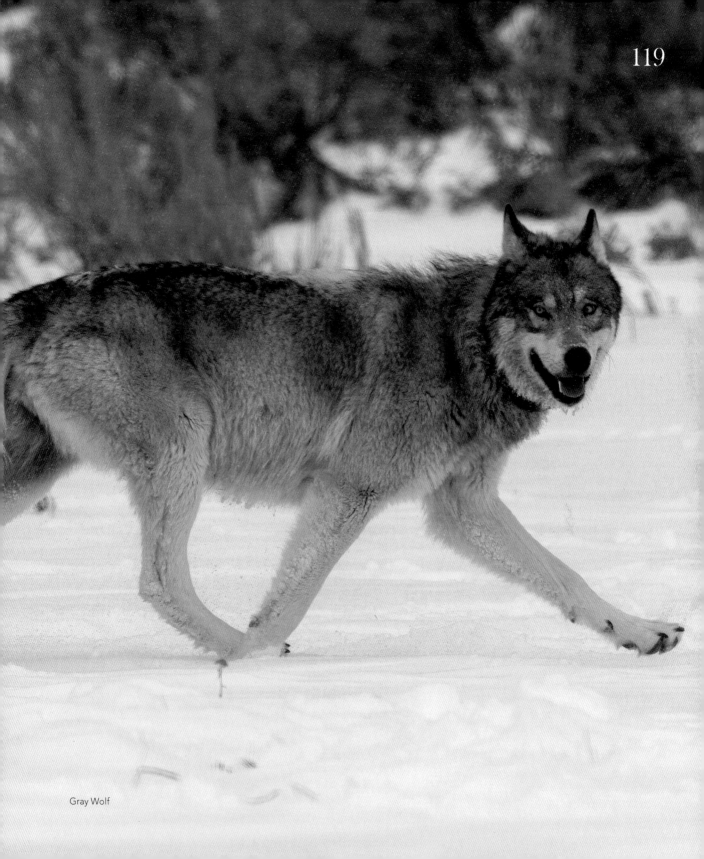

Gray Wolf

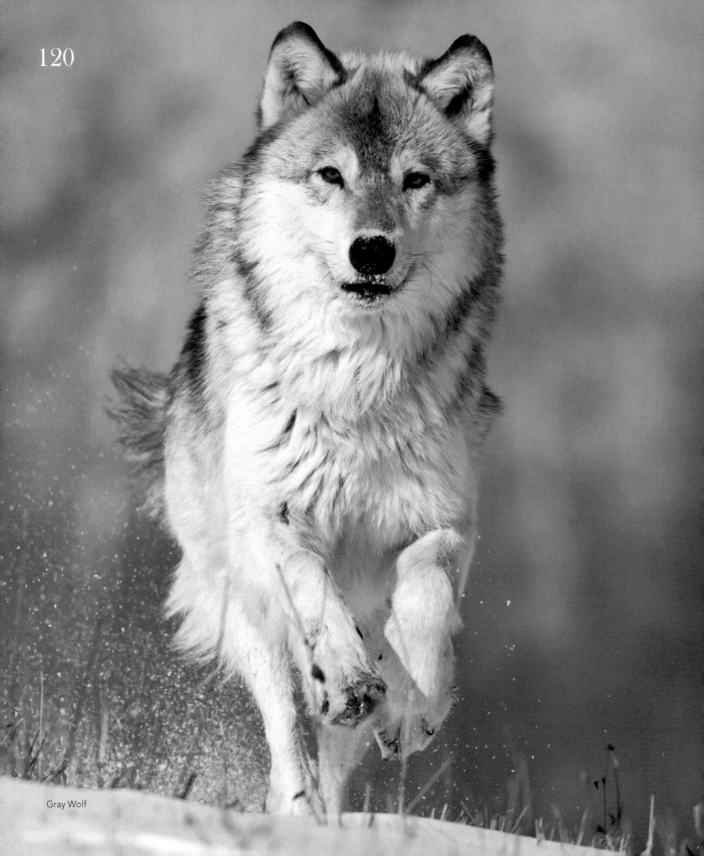

Gray Wolf

Loping and running

When a wolf travels, it lopes. This is not quite a full trot, but it's also not a walk. Due to their physical build, each foot lands almost directly in line in front of the other while walking or loping. Also, the hind feet land directly in the tracks of the front feet. This is an energy-efficient way to walk, not to mention that it helps reduce the extra noise that would have been made from the hind feet landing outside the prints of carefully placed front feet.

Wolves can maintain a tireless gait of 5-6 mph over many miles. When returning to the den with food for their young, they often travel up to 7-8 mph. They can also run at very fast speeds that are necessary for short distances when in hot pursuit, up to 40-45 mph.

Coyotes are much smaller than wolves and lack some of the overall body muscle, but they also lope and travel great distances—just at slightly slower speeds of 4-5 mph. Like coyotes, foxes also trek long distances at 4-5 mph. Their top speeds are similar to wolves and last only for short distances.

Feet geared for travel

Wolves have huge feet. Their large paws support their heavy bodies and serve them well on long journeys. Large feet help them bear their body weight while traveling in deep snow, much like snowshoes. In addition, their paws are also well furred during winter for added warmth and protection.

The proportion of foot size to body is similar in coyotes and foxes, but it doesn't come close to that of wolves. In fact, fox feet are small and narrow. In fact, fox feet are small and narrow, but since their bodies are lightweight, foxes travel easily on top of snow. Where snow isn't a factor, small feet serve both foxes and coyotes well. They can walk with little noise and minimize contact with hot surfaces such as sun-baked desert sand. This especially helps when hunting.

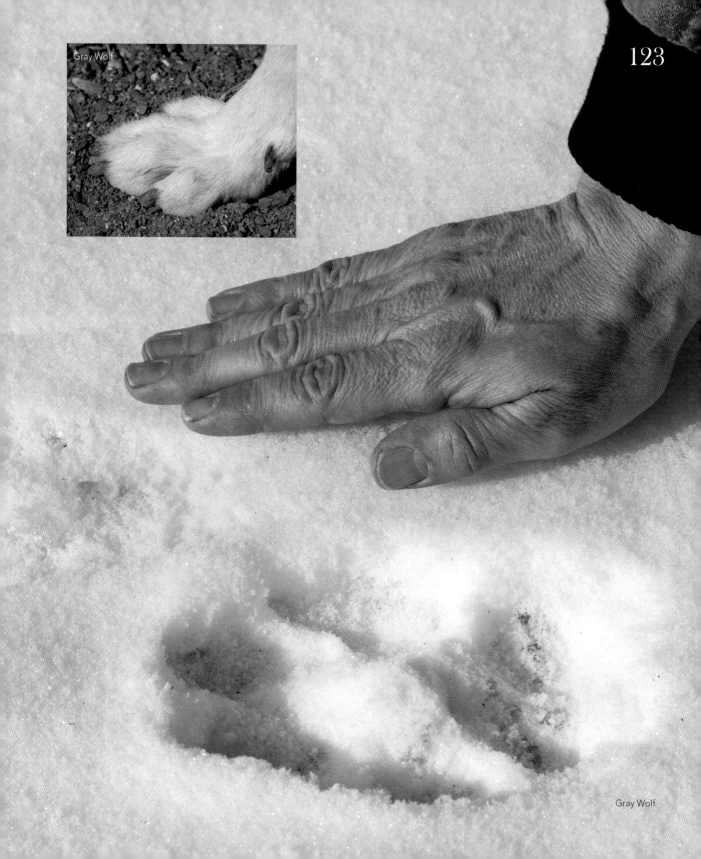

Gray Wolf

Gray Wolf

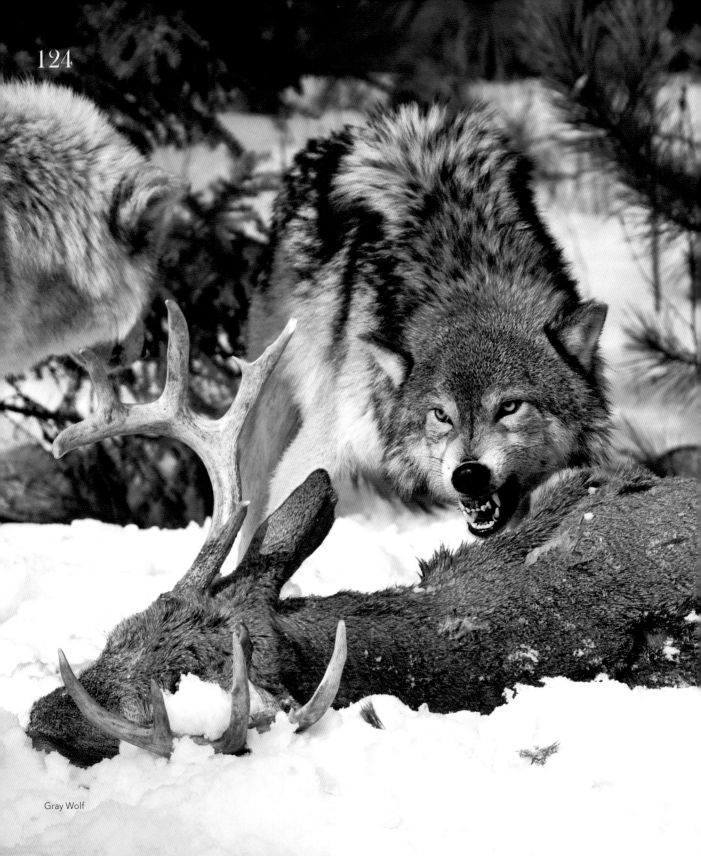

Gray Wolf

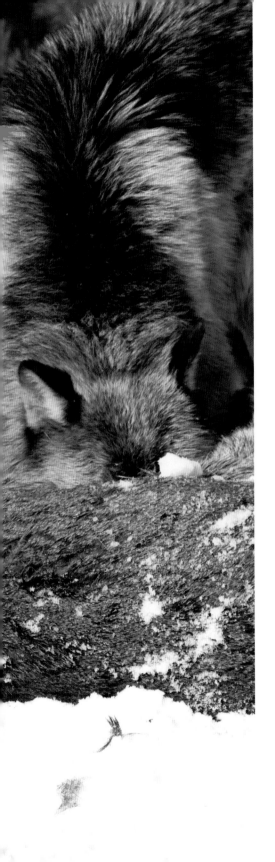

Diet

Wolves spend one-third of their lives hunting and eating. Studies show that the average adult wolf eats 15-18 deer per year. In Minnesota, which has approximately 2,600 wolves, this amounts to 39,000-47,000 deer per year. Automobiles kill equivalent numbers of deer every year and hunters take 4 times as many. Wolves must kill to survive, but they take the weak, sick and young—which helps keep deer herds healthy and strong. Vehicle collisions kill deer indiscriminately, regardless of health or age. Hunters tend to take bucks and breeding females.

In regions where elk is the main food, there is a higher ratio of elk to wolves. Elk are larger and each individual provides more food for an entire wolf pack, so fewer elk are killed. There are many places, such as Alaska, where caribou is the main source of nutrition for wolves. Since caribou are migratory, they are a food source for only part of the year. The rest of the time, the wolves subsist on hares, cottontails and small rodents such as voles and mice.

Finding, stalking and successfully taking down large deer, elk, bison, moose and caribou is difficult and extremely dangerous. These animals outweigh wolves by 2-4 times and sometimes much more, so it's not uncommon for a wolf to be killed in the process. During photography for this book, I learned about an alpha female wolf that had been killed by a single kick of a bison—a traumatic event resulting in the breakup of the entire pack.

Coyotes survive on a different diet. They are only about one-quarter the weight of a full-grown deer, so the odds for a successful large kill are stacked against them from the start. It is fairly uncommon for a coyote to catch and kill an adult deer. When a coyote pack works together, often it is a sick, young or frail individual that is targeted and brought down.

The main diet for coyotes and foxes is the same. Small mammals, such as voles, mice and shrews, are the main course. They will also use any opportunity to catch and eat a rabbit, hare, chipmunk, woodchuck or other small to medium animal. Of course, coyotes and foxes are well known to feed on the leftovers of a wolf kill or even roadkill.

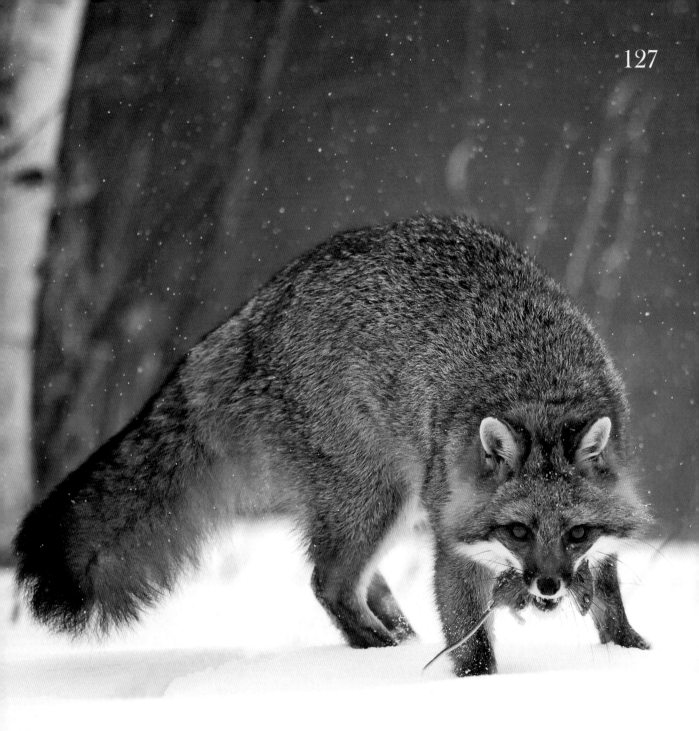

Gray Fox

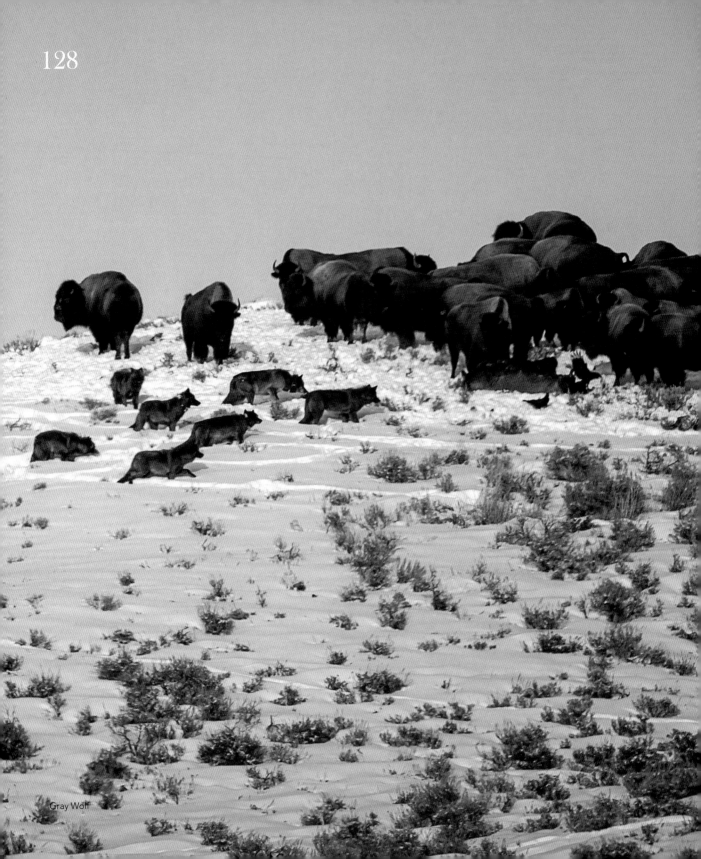

Gray Wolf

Feast-or-famine feeding

Wolves often go days or sometimes even weeks without eating because they cannot find food or kill any prey. They either kill and eat, or die. There are no alternatives. It is common for wolves to go 3-4 days without eating, although one researcher reported a wolf that went nearly 2 weeks with no food.

The digestive system of wolves is well equipped for their feast-or-famine diet. After a kill, they will gorge themselves, often consuming up to 18 pounds of meat. During the feeding frenzy they also chew and swallow bones and fur. Once their bellies are full, wolves usually lie down for half the day, digesting.

When the prey is deer, moose, elk or bison, wolves will eat the muscle meat, fatty tissue and all the organs, such as heart, lung and liver, ignoring the stomach and its contents. They wash down the meal with copious amounts of water, which prevents uremic poisoning from the high production of urea associated with an all-meat diet. Wolves are also known for their ability to eat rotten flesh without suffering any ill effects later.

Coyotes and foxes don't experience as much feasting and famine, so their feeding is slightly more consistent. They will fill up on large amounts of meat, however, when the opportunity arises. Like wolves, they will also lie down for long periods after large meals, but usually they are eating smaller proportions and napping for shorter periods before heading out to hunt for the next morsel.

Traditions in courtship

Finding a mate or forming a new pair can occur at any time of year. Once a male and female wolf find each other and establish a pair bond, they often remain together year-round. They delineate a new territory and usually patrol it together, putting down scent marks that convey they are a mated couple.

Scent marking with each other is a big part of wolf courtship. Pairs will scent mark more frequently than lone wolves or other wolves in the pack without mates. New couples scent mark much more frequently than well-established pairs.

Courtship in wolves starts about 2 months before the breeding season, which runs from late January to early March. Couples spend more time together during courtship than at any other time, standing nearer and walking closer to each other, slightly separated from the other pack members. Mated pairs nuzzle more and prance in front of each other. They also will sleep close together, especially after breeding starts. At this stage, their feelings for each other are obvious.

Hormones drive the mating behaviors in each pair, and mates spend more time investigating each other's genital scent glands. At some point, their hormone levels match, causing the pair to become synchronized. From here on, the male and female progress through the same fixed sequence of mating behaviors simultaneously.

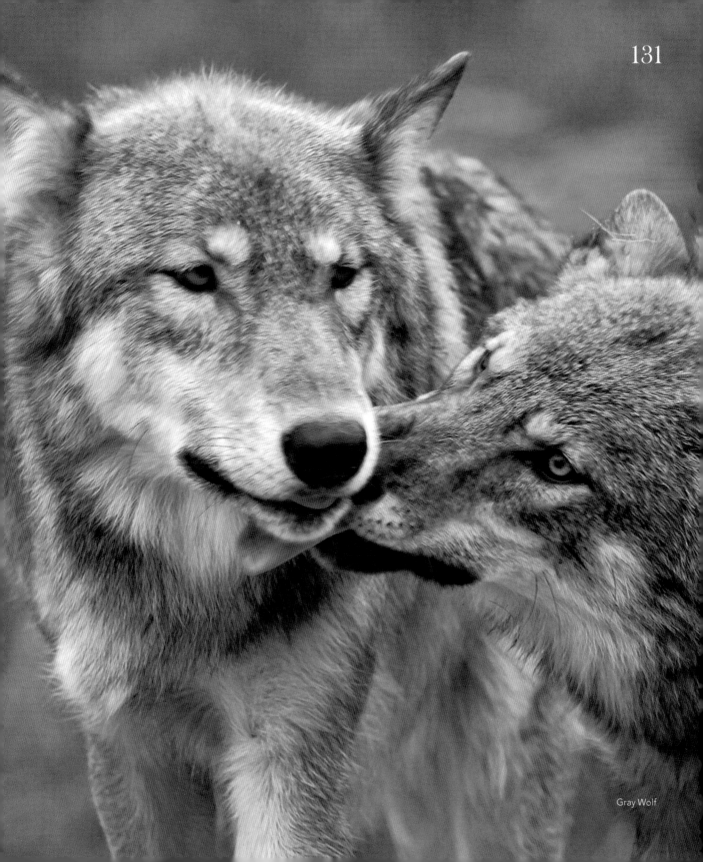

Gray Wolf

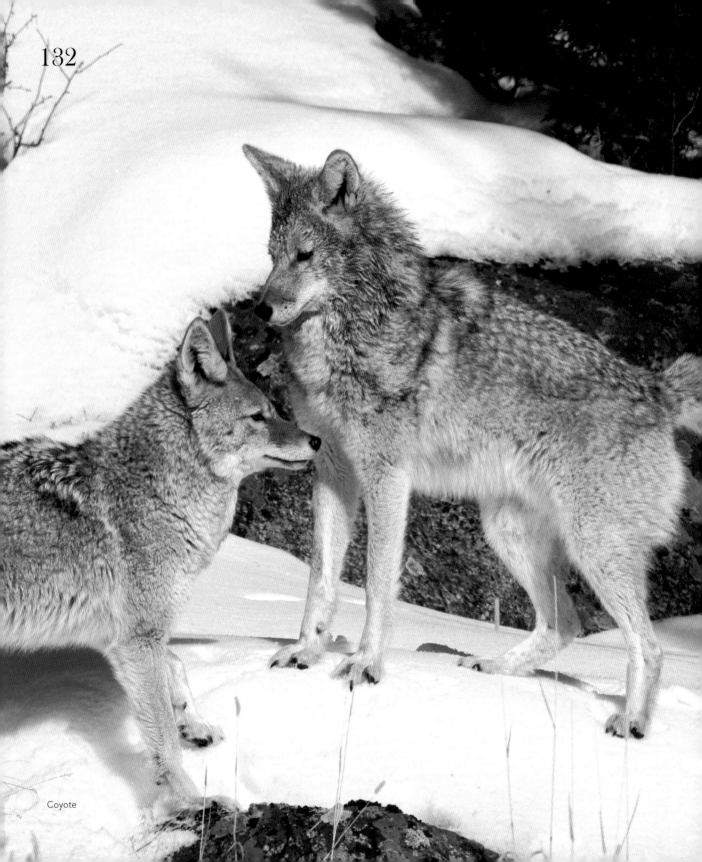

Coyote

Mating affairs

Wolves breed only once a year, unlike dogs. Males become reproductively active starting in October and November and stay that way until March. The changing amount of daylight, called the photoperiod, is responsible for the surge in their testosterone production.

Female receptivity to mating lasts only 8-18 days. A female will not tolerate any mounting until she is in the proestrus phase (full heat). At this time she presents with a bloody discharge that is visually evident when she walks, just like female domestic dogs.

Now the female is actively soliciting the attention of her mate. She will prance, paw and nuzzle him, and she may even go as far as resting her chin on his back. In addition, the male will roll on a smelly object or in blood and use the scent to entice the female he is trying to impress. This active phase lasts up to 2 weeks.

Denning

Wolves don't make homes of their dens. They use dens only for 8-9 weeks following the birth of pups. After the young leave the dens, the wolves do not return, preferring to sleep outside.

Females choose the den site and do most of the digging. Studies of captive wolves show that female orphans will dig dens without instruction or example, indicating that this behavior is innate.

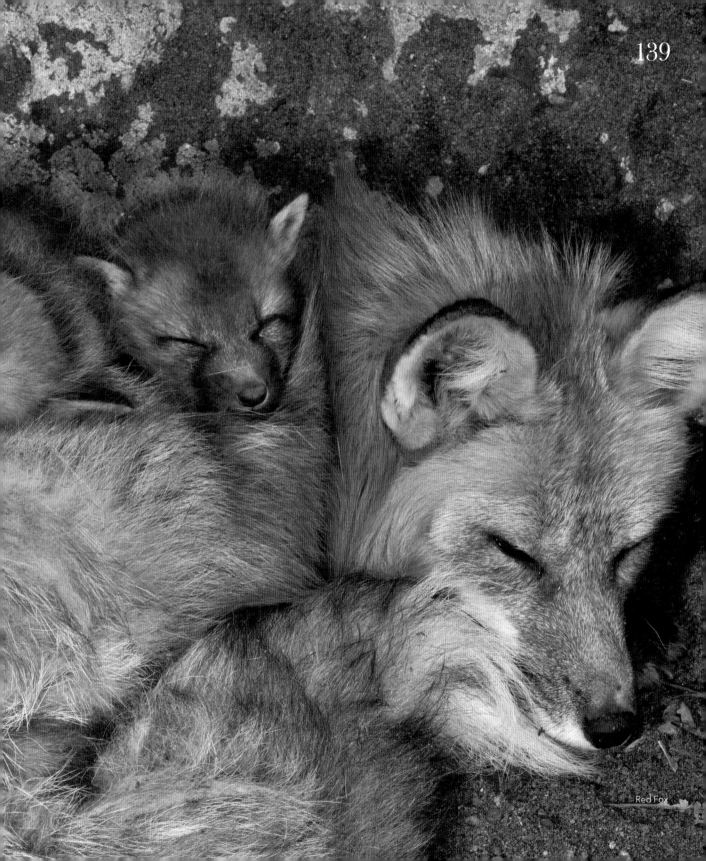

Red Fox

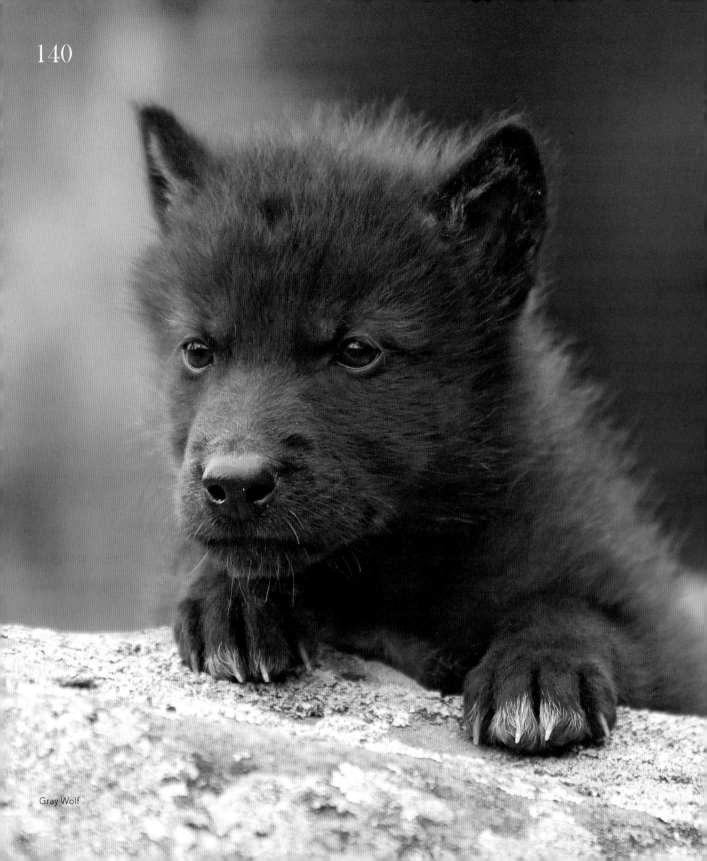

Gray Wolf

Breeding and gestation

Breeding season extends from late January to early March, but most mating occurs in February. The gestation period for wolves is 62-63 days. In places such as Minnesota, Wisconsin and the Rocky Mountains, pups are usually born from early April to early May. Mating and births occur slightly later in northern regions such as Alaska and northern Canada.

The breeding season for coyotes and foxes occurs at about the same time as wolves, with a slightly shorter gestation period of 50-53 days. While the wolf and coyote breeding seasons are fairly regular each year, Red and Gray Foxes sometimes breed earlier and produce litters much sooner. In fact, I have witnessed the birth of Red Fox pups as early as the first week in March.

Litter success

The average litter size for a healthy adult female wolf is 6 pups. The youngest documented female wolf to breed in the wild was 2 years of age, but most other young females just starting to reproduce are often unsuccessful the first time. They lack proper nutrition and also mating skill, since their pack usually consists of just themselves and their mate. As they age and get more experience, chances for success increase greatly.

Young coyote and fox mothers tend to have more success from the start than wolves. Coyotes produce 4-6 pups and Swift Foxes have up to 8 kits, while Red and Gray Foxes have as many as 10 kits. Foxes tend to live shorter lives than wolves and birth more young earlier in life, which is proportionate for their shorter life spans.

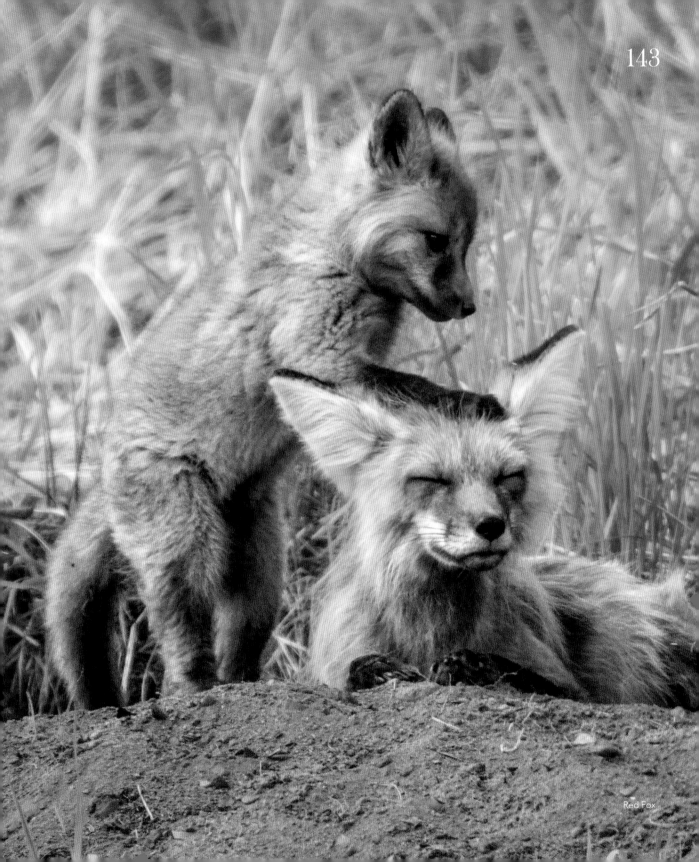

Red Fox

Swift Fox

Birth and development

All canid pups are born with eyes closed and ears sealed shut, and they are completely helpless. They have thin, fine fur, and within hours they are suckling milk. The mother stays with the pups constantly, mainly to keep them warm. She will only leave the den to urinate and be fed by her mate. When she returns, she positions herself so the pups can snuggle against her belly. She may lick the rears of her pups to stimulate them to urinate and defecate. Afterward she consumes their waste, which helps keep the den clean and dry.

Pups open their eyes at 12-14 days and start to move about and interact with their littermates. Eyesight is not well developed at this time, so they stumble around the dark den. Their eyes appear light blue in color.

At 20-24 days, the pups make their way to daylight at the den entrance. They spend increasingly more time outside the entrance at 4-5 weeks, playing and sunning themselves. This is an important time because they are starting to meet the adults in the pack for the first time. Their eyes are darker now, and the pups start to look like they will as adults.

Canid pups spend a lot of time roughhousing at the den site. Leftover bones and fur from other meals become toys, and play-fighting and wrestling is a big part of their life. Wrestling, playing, stalking and pouncing helps them build muscles, practice skills, learn limitations and determine the litter's pecking order. Much socialization occurs at this time and continues as they grow. Considering how important social interactions are in canids, these early behaviors are vital.

At 5-6 weeks, the pups have grown up enough to seek shelter when needed, but they're still small enough for the mother to carry around. They are still feeding on milk and tall enough now to suckle from their mother while she is standing.

A big jump in development happens during ages 6-10 weeks. Pups change from toddlers to active members of the pack. Most notable is that the pups are starting to eat solid foods. Now each nursing session is less than a minute and spaced far apart. By week 10, the pups have been weaned from their mother's milk.

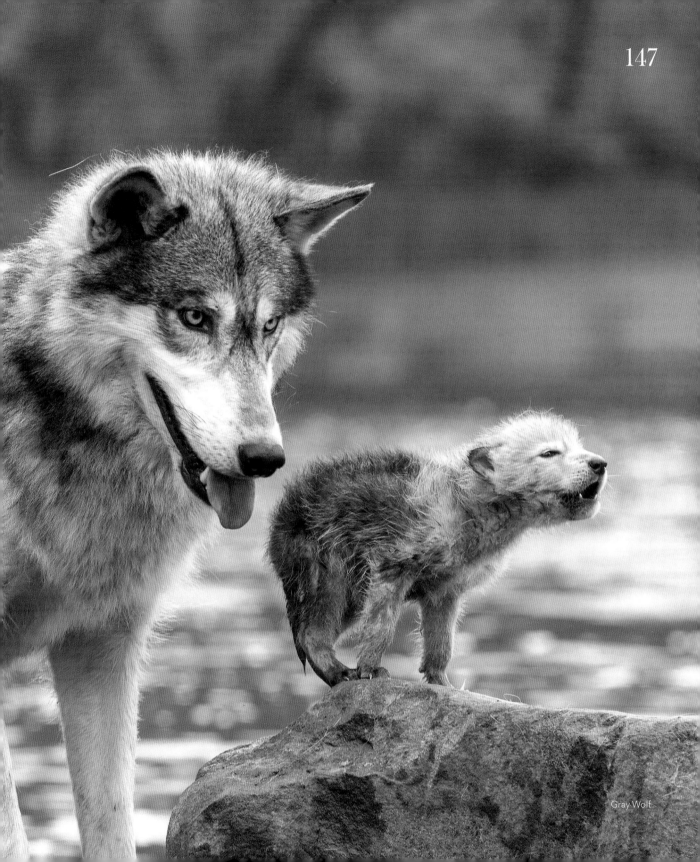

Gray Wolf

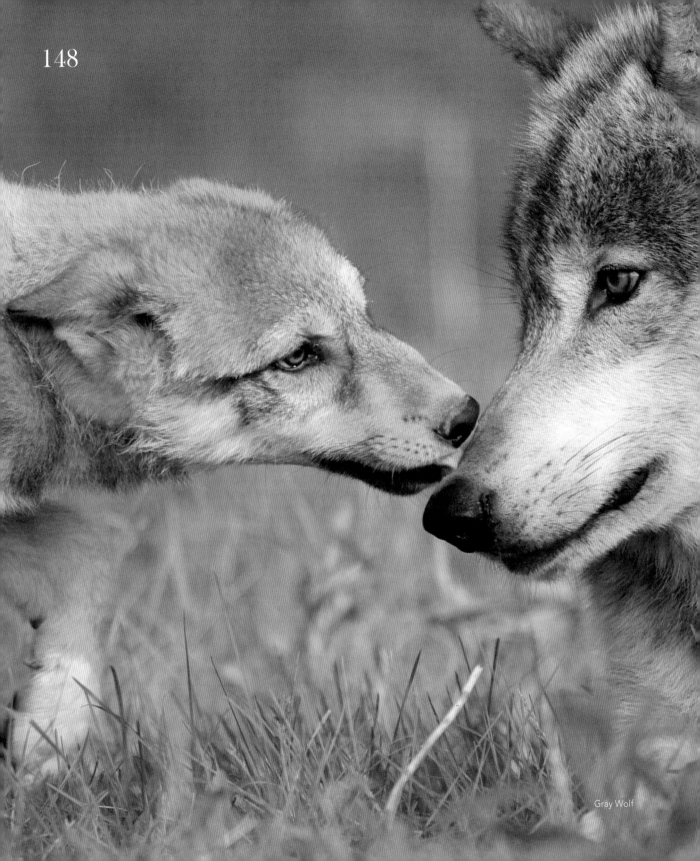

Gray Wolf

Licking up feeding

Feeding pups at the den is a fast and furious event. When adults return from a hunt, the pups rush up to them and start to lick their mouths. This behavior, called licking up, stimulates the adults to regurgitate food for the pups. Licking up is the main way pups are fed while they're still too small to follow the pack.

Providing nourishment for growing pups is a full-time job for the entire pack. Sometimes adults will carry a leg bone back for the pups to gnaw.

In addition to the parents, nearly all adult pack members will regurgitate food for the pups. When the adults regurgitate, the pups quickly gobble all the available food. Each pup must grab and swallow its own share. All of this happens in a matter of seconds and is the source of the phrase, "Wolf down your food."

An adult wolf returning with a full belly will usually regurgitate about 4 pounds of meat. However, the amount of regurgitated food ranges widely and can weigh 3–16 pounds.

In coyotes and foxes, regurgitated amounts are significantly less, being proportional to their body sizes. Coyotes typically regurgitate about 2 pounds, while foxes regurgitate up to 1 pound.

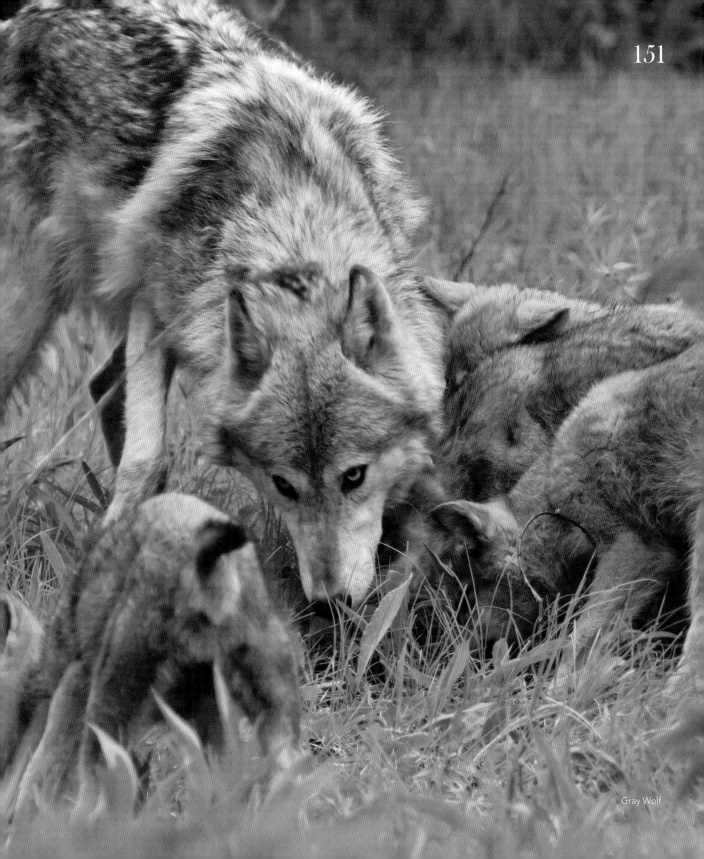

Gray Wolf

Swift Fox

Learning to hunt

For any of the wild canids, learning to hunt is critical for survival. The desire to hunt and many of the skills needed to hunt and kill small game are innate in these animals. Starting at about 3 months, the pups follow their parents for short excursions and begin hunting around the den site by themselves. Pups stalk and pounce on their littermates from an early age and continue to practice these behaviors, which are essential for their future.

Hunting mice and other small mammals is not a behavior that must be learned by watching and copying the parents. Coyote and fox pups catch small prey naturally, without instruction. Hunting rabbits, on the other hand, is a skill that needs to be taught. A rabbit's speed and skill at evading predators makes it necessary for pups to learn and practice a different hunting method before they get good at catching rabbits.

At 4 months of age, young wolves are not fully grown, but they are fully capable of following the pack and learning cooperative hunting. For a pack to take down much larger prey, the wolves must work together. Participating in a pack hunt teaches the young all the skills they need to know for their future, whether they are hunting in a pack or when they are on their own.

In young coyotes and foxes, which hunt mainly small animals, the survival skill for capturing mice, voles and rabbits is instinctive and only needs refining with a little training and practice. Their natural curiosity, keen sense of smell, sharp eyes and lightning reflexes work in concert to help them catch prey. When coyotes hunt with each other, however, the effort requires a high level of cooperation.

Lives of wolves

Wolves are not so different from our own domestic dogs, and they hold a very special place in my heart. Each time I get a chance to see or photograph one or more of these wild canids, I am thrilled beyond words. Every encounter is remarkable and memorable.

The coyote is an amazing species that has survived despite more than 200 years of intense persecution and bounties. Not only that, it has even expanded its range! I stand in admiration of these feats, with all respect due the coyote.

Foxes are interesting canids, filling a unique niche in nature. Not only are they beautiful, they provide a great service to us by eating small rodents. Foxes usually go unnoticed in wild places because they are shy, but they often will reside more visibly in suburban backyards. Wild foxes on the property make extremely good neighbors, and I'm always delighted to see them.

Wolves are a symbol of all things wild. They indicate an intact ecosystem, complete with top predators. As stewards of the environment, we have the responsibility to keep the ecosystem balanced by maintaining and supporting all wildlife, including animals such as wolves, coyotes and foxes. In my view, it's an honor and a privilege to share in the appreciation and safekeeping of our wild and wonderful wolves.

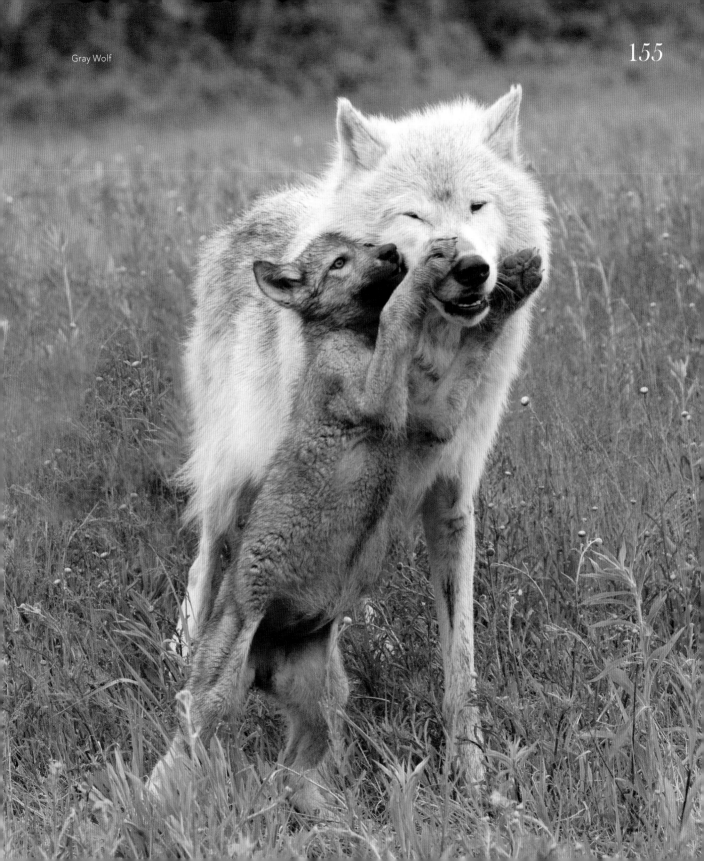

Featured canines

This photo spread shows all nine wolf, coyote and fox species in the United States and Canada and their ranges. Ranges shown in dark red indicate where you would most likely see the animals during the year. Former ranges are shown in tan. Like other wildlife, wolves, coyotes and foxes move around freely and can be seen at different times of the year both inside and outside their ranges. Maps do not indicate the number of individuals in a given area (density).

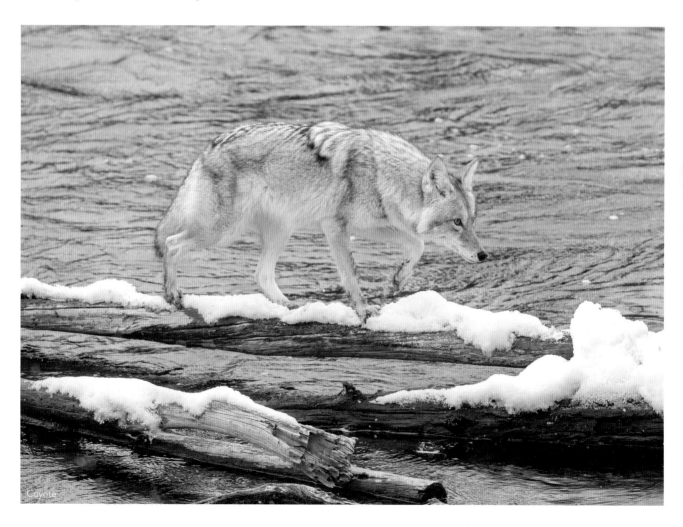
Coyote

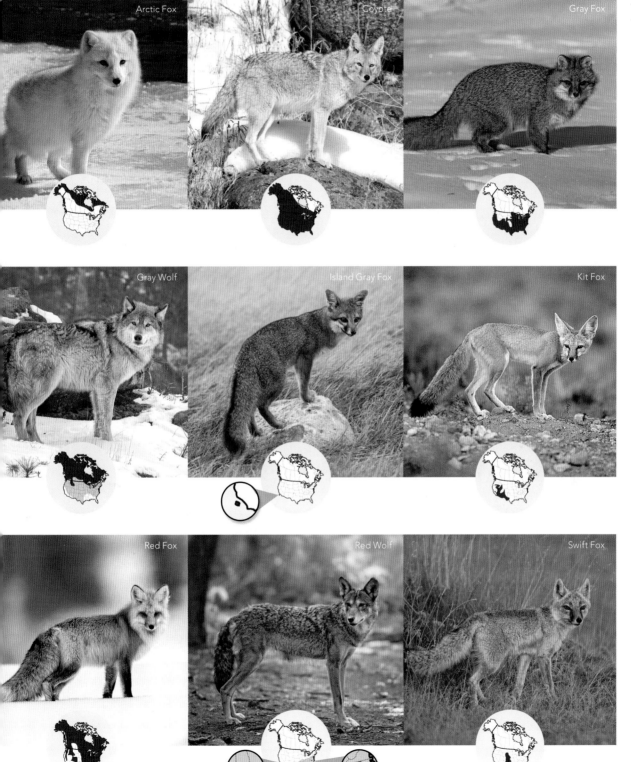

Arctic Fox

Coyote

Gray Fox

Gray Wolf

Island Gray Fox

Kit Fox

Red Fox

Red Wolf

Swift Fox

Wolf-centric projects and conservation groups

The following is a necessarily incomplete list of organizations involved in wolf and canid conservation. Some even have resident on-site wolf populations and visitor centers. For details, visit the websites below.

Voyageurs Wolf Project; Voyageurs National Park and surrounding region, Minnesota
www.voyageurswolfproject.org

Wildlife Science Center; Stacy, Minnesota
www.wildlifesciencecenter.org

International Wolf Center; Ely, Minnesota
https://wolf.org

Wolf Conservation Center; South Salem, New York
https://nywolf.org

Wolf Sanctuary of Pennsylvania; Lititz, Pennsylvania
https://wolfsanctuarypa.org

Where to (possibly) see wolves in the wild

If you want to visit a location where you can have a chance to spot a wolf in nature, consider a visit to one of these wild places, which are all known for their wolves. Note: Spotting a wolf in the wild is certainly not guaranteed on a trip, and this list is not all-inclusive.

Yellowstone National Park; Wyoming, Montana, Idaho
www.nps.gov/yell/index.htm

Grand Teton National Park; Wyoming
www.nps.gov/grte/index.htm

Voyageurs National Park; Minnesota
www.nps.gov/voya/index.htm

Boundary Waters Canoe Area Wilderness; Minnesota
www.recreation.gov/permits/233396

About the author

Naturalist, wildlife photographer, and writer Stan Tekiela is the originator of the popular Wildlife Appreciation series that includes *Cranes, Herons & Egrets*. Stan has authored more than 190 educational books, including field guides, quick guides, nature books, children's books, and more, presenting many species of animals and plants.

With a Bachelor of Science degree in natural history from the University of Minnesota and as an active professional naturalist for more than 30 years, Stan studies and photographs wildlife throughout the United States and Canada. He has received national and regional awards for his books and photographs and is also a well-known columnist and radio personality. His syndicated column appears in more than 25 newspapers, and his wildlife programs are broadcast on a number of Midwest radio stations. You can follow Stan on Facebook, Instagram, and Twitter, or contact him via his website, naturesmart.com.